FRED PICKER

6/22/79

For Bill
with Warm Regard,
Fred.

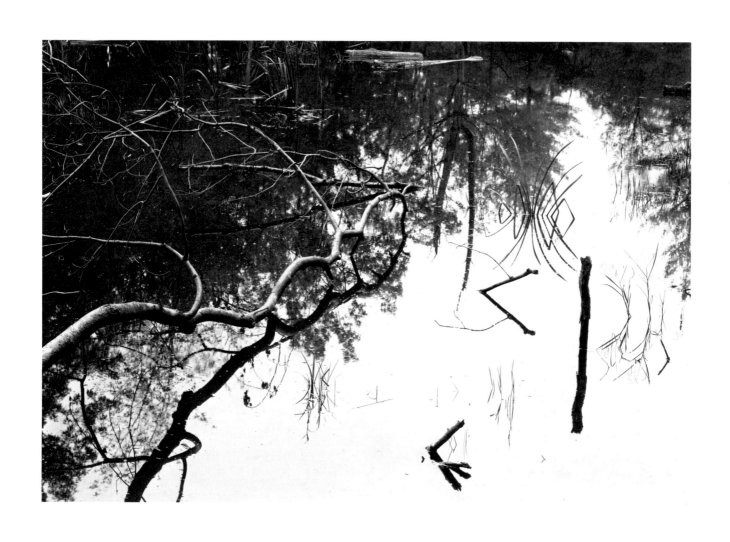

1. DUMMERSTON, VERMONT, 1979

FRED PICKER

AMERICAN
PHOTOGRAPHIC
BOOK PUBLISHING
COMPANY, INC.

Fred Picker is the author of "The Zone VI Work-shop," "The Fine Print," "Rapa Nui" (Easter Island) with Thor Heyerdahl, and "The Iceland Portfolio." He designs and markets photographic equipment, publishes a quarterly newsletter, directs a summer workshop program, and is a consultant to the Polaroid Corporation. He has been a trustee of The Friends of Photography and is a panel member of The Vermont Council on The Arts. His home is in Dummerston, Vermont.

For the constant encouragement and patient understanding that contributed to the making of these photographs and for her guidance in the selection and arrangement of them, I gratefully acknowledge the contribution of Lillian Farber to this book.

This book is published to accompany an exhibition at the Prakapas Gallery, New York, in June, 1979. The photographs were made between 1972 and 1979.

Design by Lance Hidy, Lancaster, N.H.
Typesetting by Monotype Composition Co., Boston
Printing by Thomas Todd Co., Boston
Binding by the New Hampshire Bindery, Concord
The paper is Warren's Lustro Offset Enamel

James Agee, "Let Us Now Praise Famous Men" reprinted by permission of Houghton Mifflin Company, copyright © renewed 1969 by Mia Fritsch Agee.

For in the immediate world, everything is to be discerned, for him who can discern it, and centrally and simply, without either dissection into science, or digestion into art, but with the whole of consciousness, seeking to perceive it as it stands: so that the aspect of a street in sunlight can roar in the heart of itself as a symphony, perhaps as no symphony can; and all of consciousness is shifted from the imagined, the revisive, to the effort to perceive simply the cruel radiance of what is.

James Agee
from *Let Us Now Praise Famous Men*

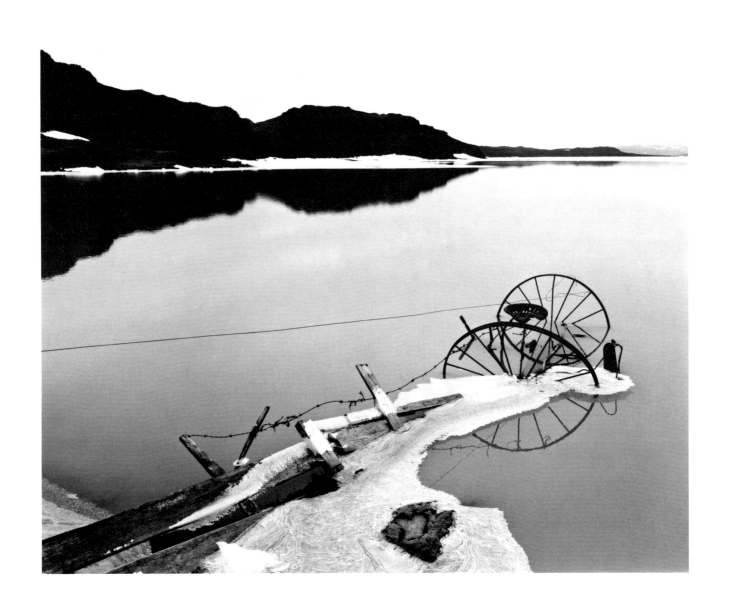

2. EGILSTADIR, ICELAND, 1975

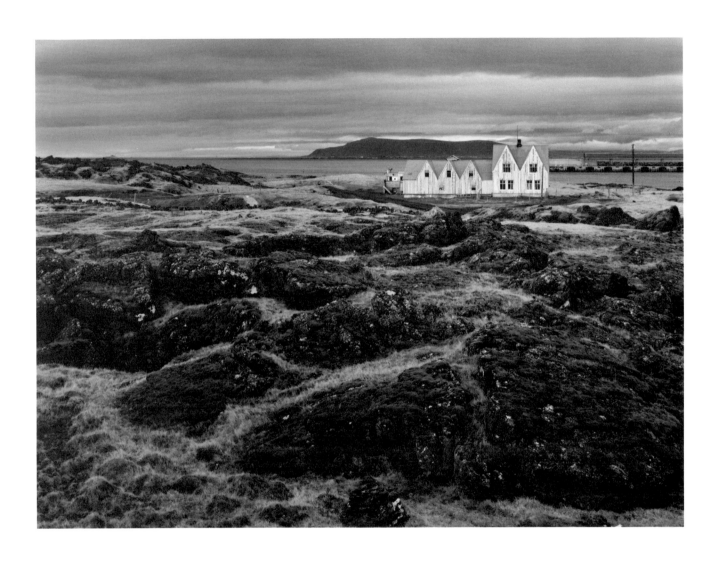

3. VOGAR, ICELAND, 1975

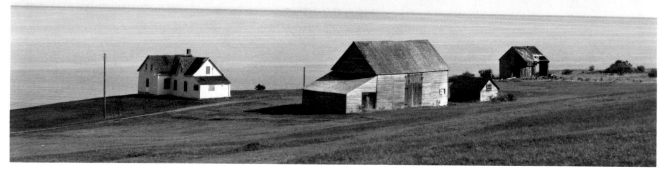

4. GASPÉ, QUEBEC, 1977

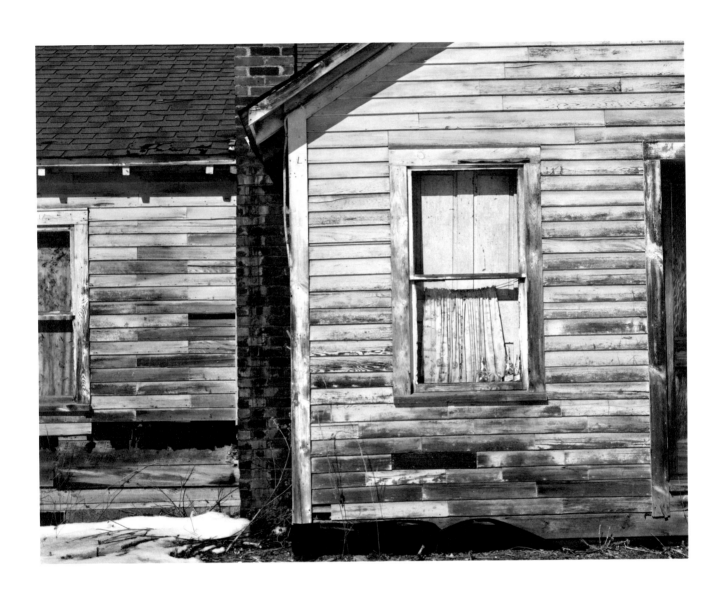

5. HIGHGATE SPRINGS, VERMONT, 1976

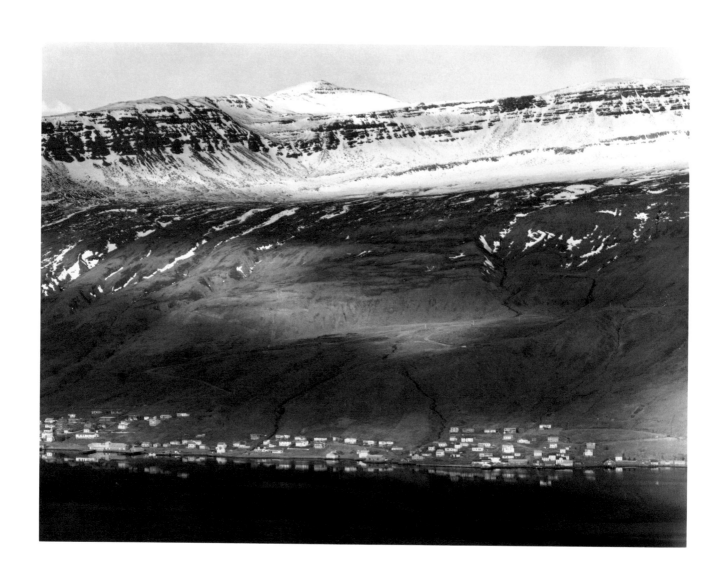

6. ESKIFJORDER, ICELAND, 1974

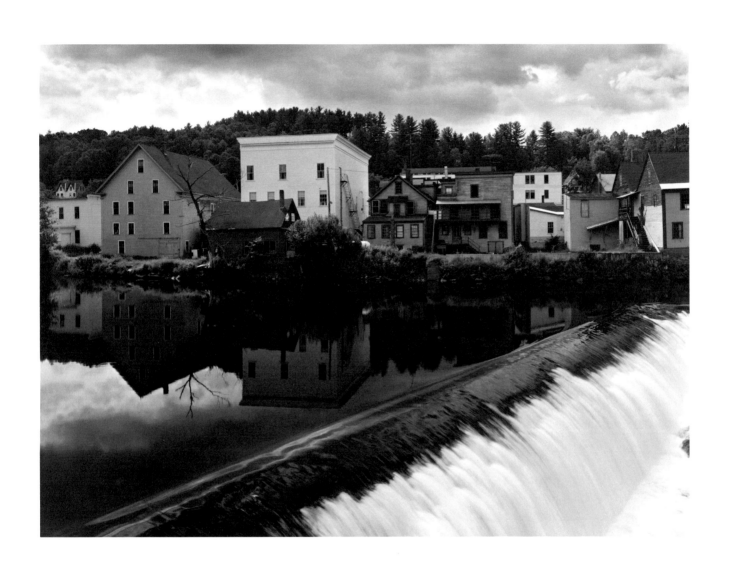

7. LISBON, NEW HAMPSHIRE, 1976

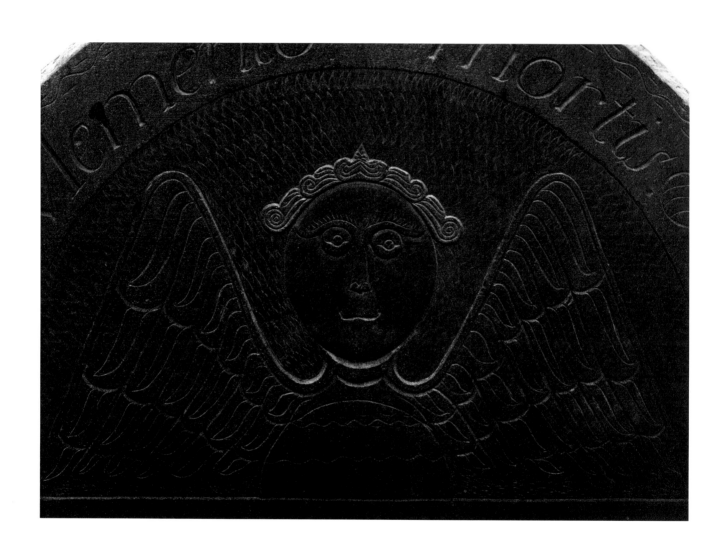

8. ROCKINGHAM, VERMONT, 1975

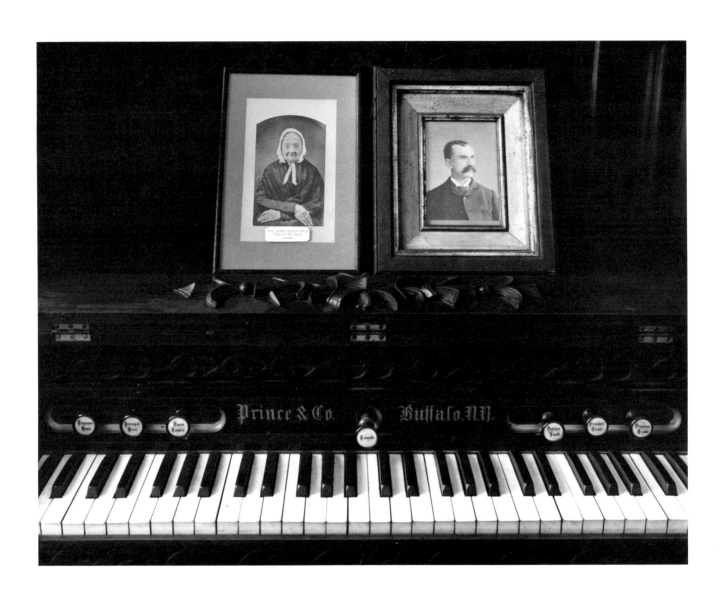

9. SOUTH WARDSBORO, VERMONT, 1976

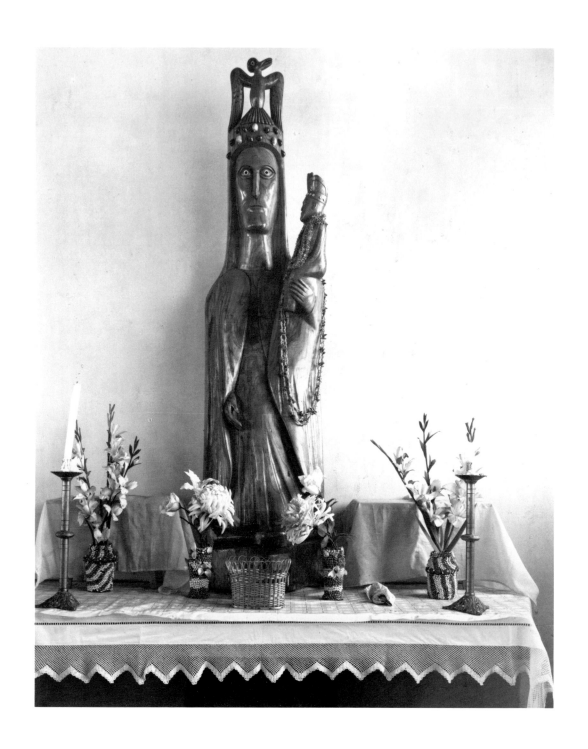

10. EASTER ISLAND, 1973

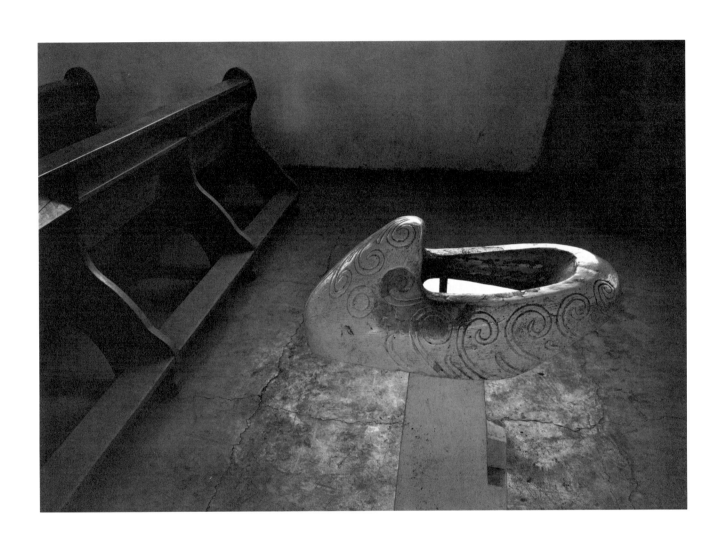

11. EASTER ISLAND, 1973

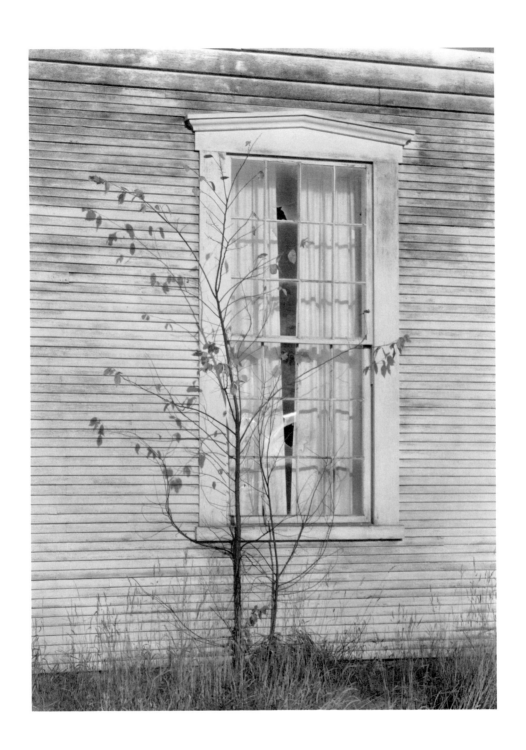

12. RIPTON, VERMONT, 1976

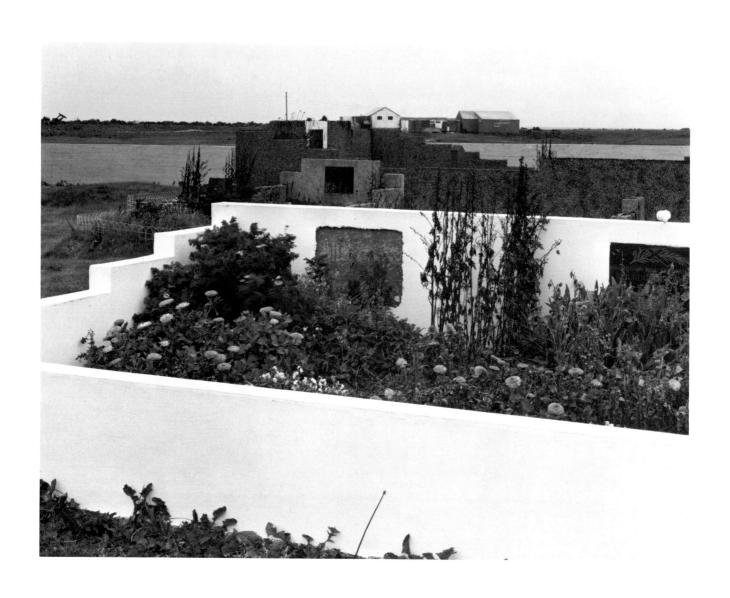

13. GERDAR, ICELAND, 1974

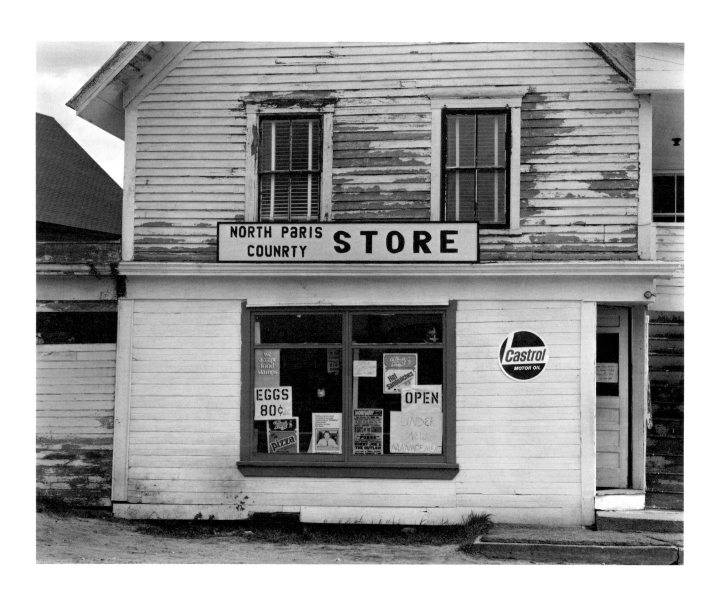

14. NORTH PARIS, MAINE, 1976

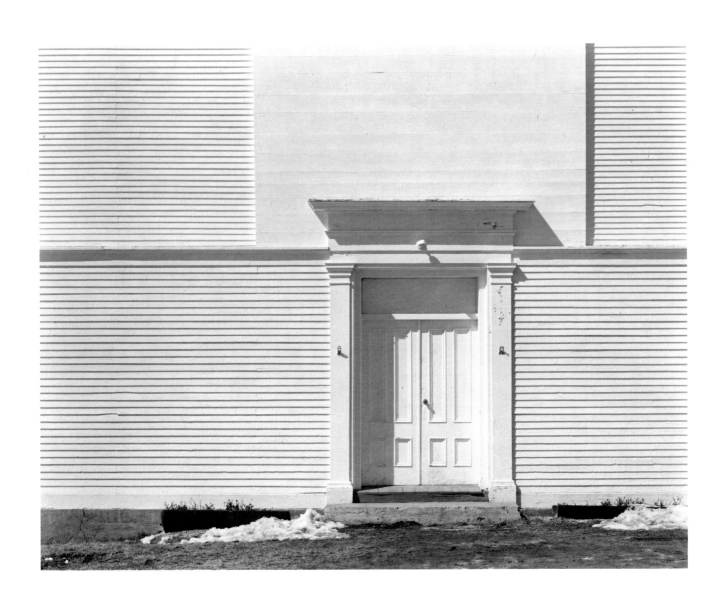

15. LOWER GRANVILLE, VERMONT, 1978

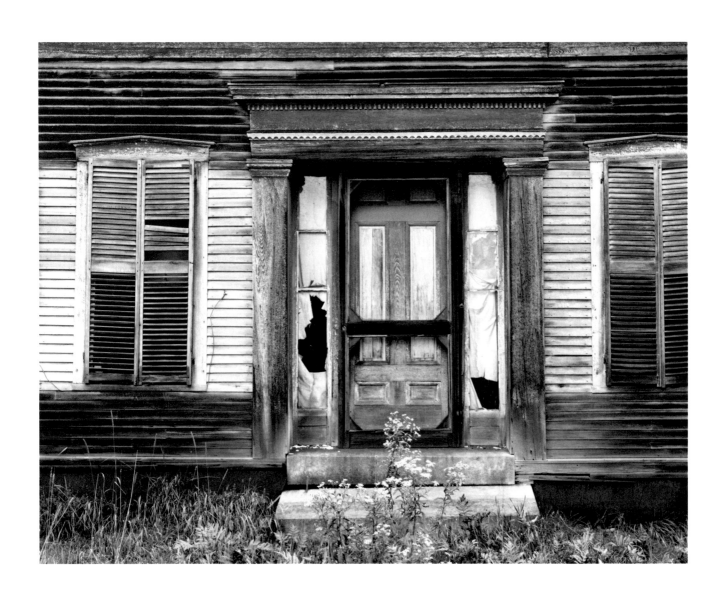

16. NORTH THETFORD, VERMONT, 1977

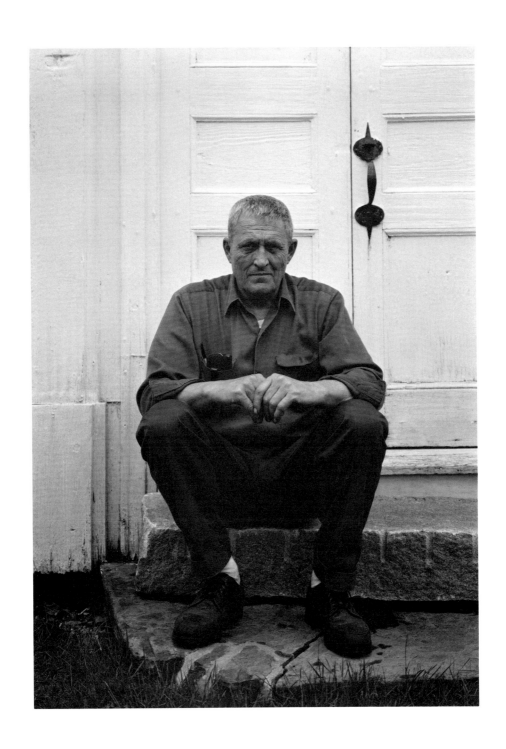

17. WILLIAM CAPEN, ROCKINGHAM, VERMONT, 1975

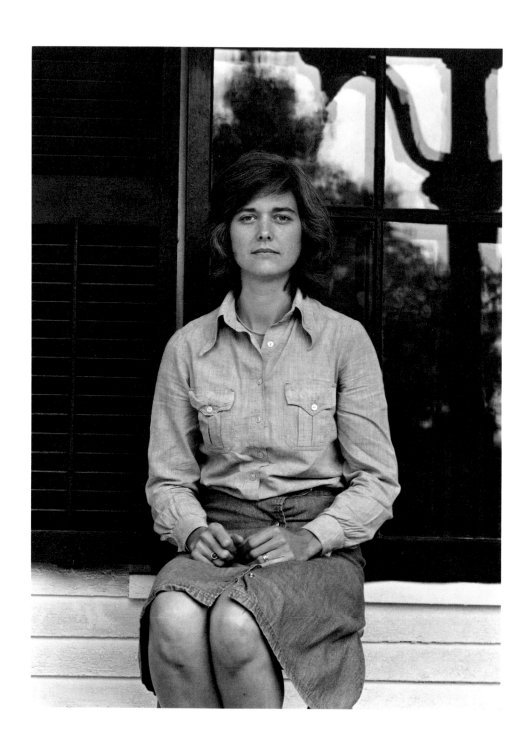

18. PAMELA SOPER, PUTNEY, VERMONT, 1976

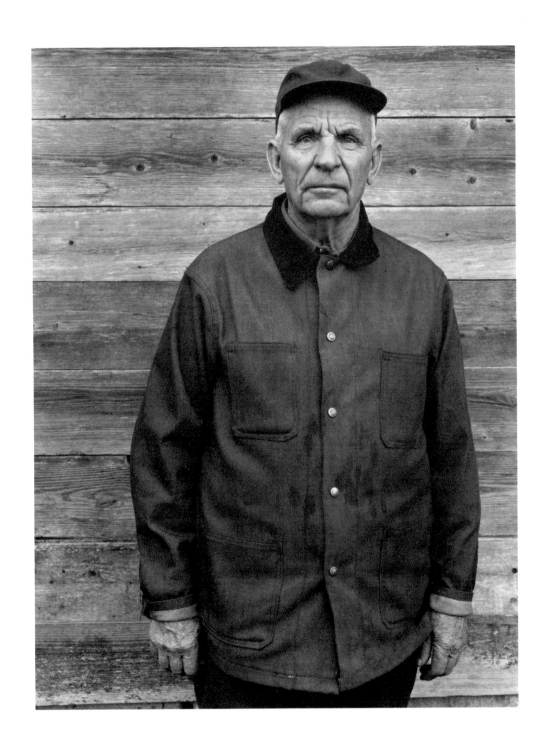

19. LEON STANLEY, VICTORY, VERMONT, 1975

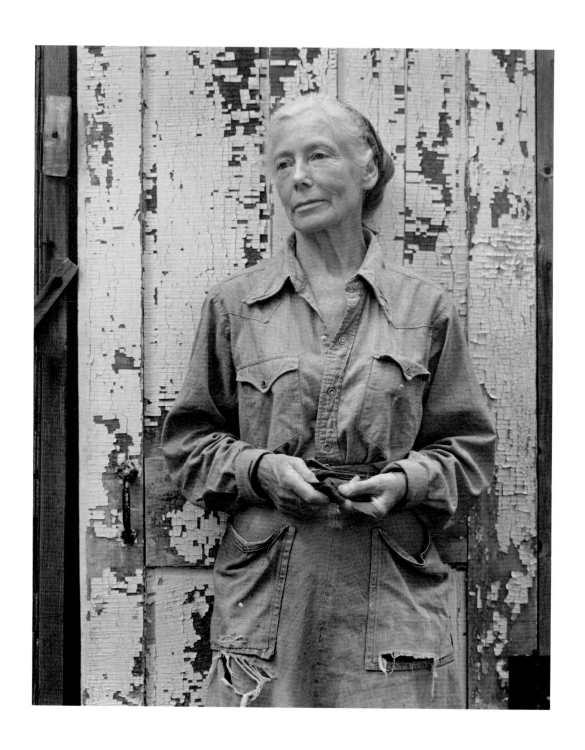

20. DORRIT MERTON, WESTMINSTER WEST, VERMONT, 1976

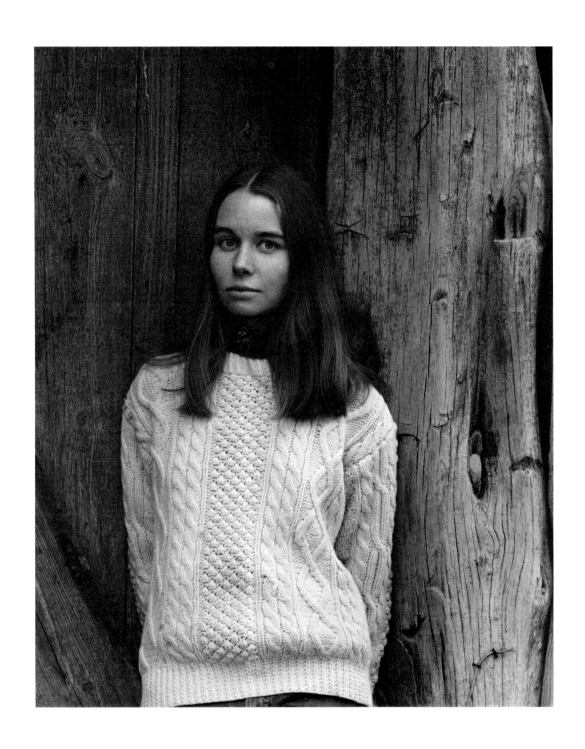

21. ANN McBROOM, PUTNEY, VERMONT, 1976

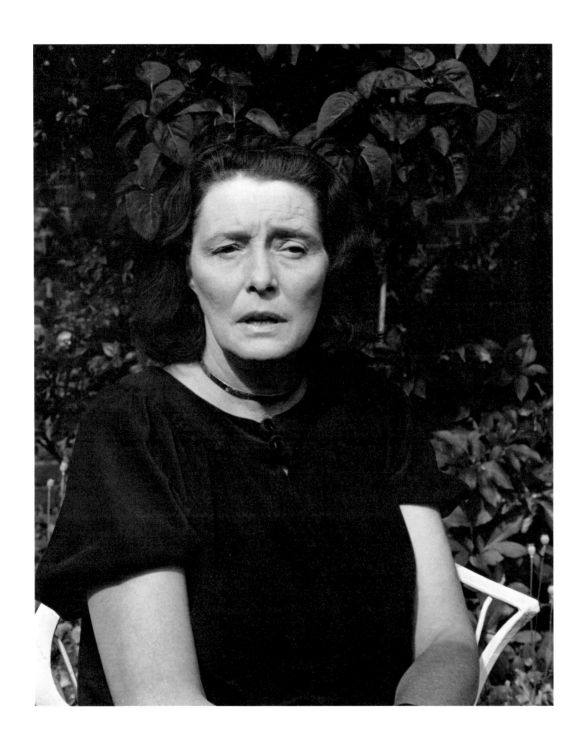

22. PATRICIA NEAL, LONDON, 1978

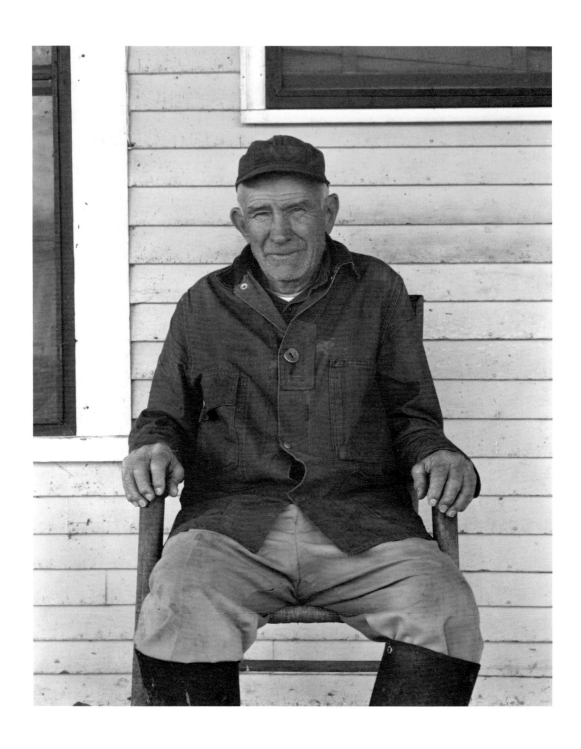

23. GEORGE STANLEY, VICTORY, VERMONT, 1976

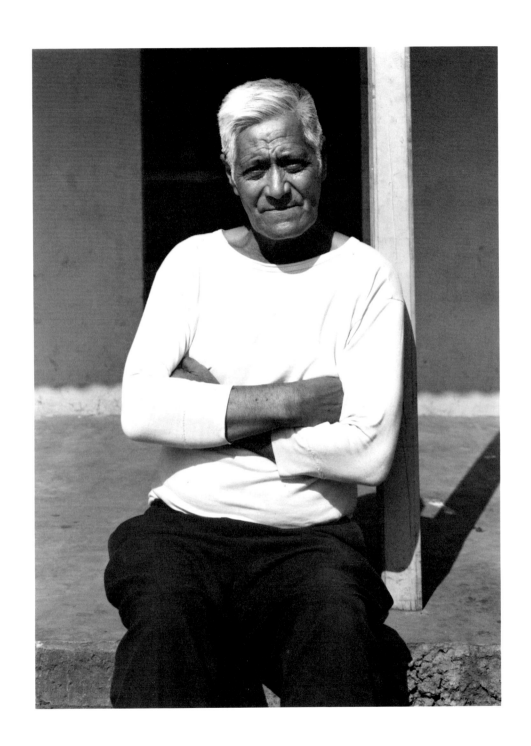

24. LEON TUKI HEI, EASTER ISLAND, 1973

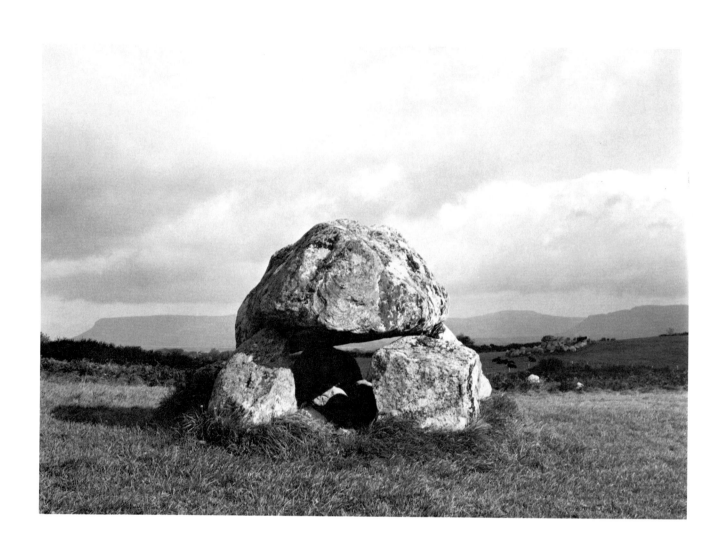

25. MEGALITHIC TOMB, SLIGO, IRELAND, 1978

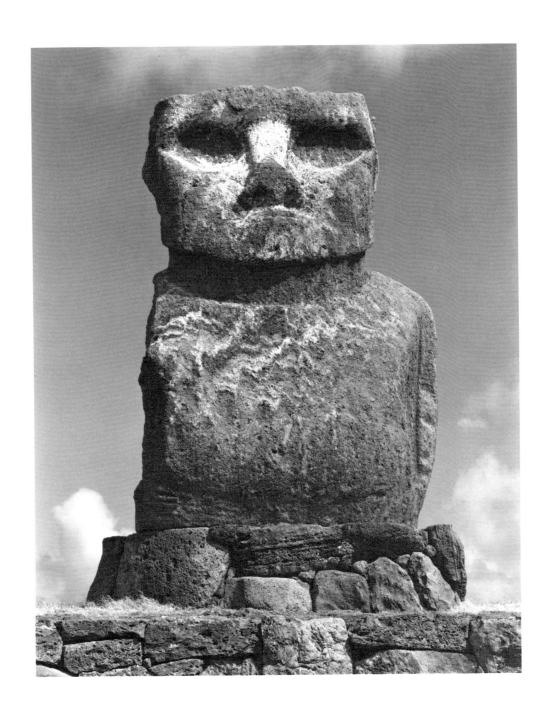

26. MOAI, EASTER ISLAND, 1973

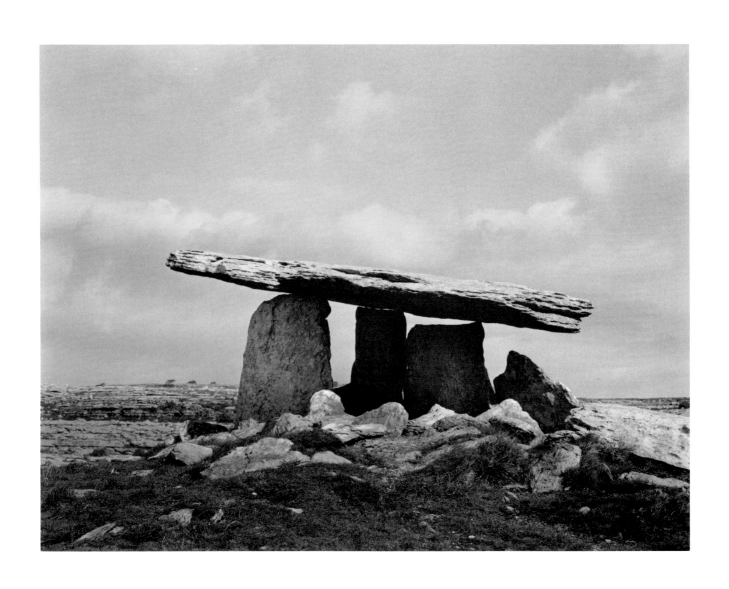

27. MEGALITHIC TOMB, BALLYVAUGHAN, IRELAND, 1978

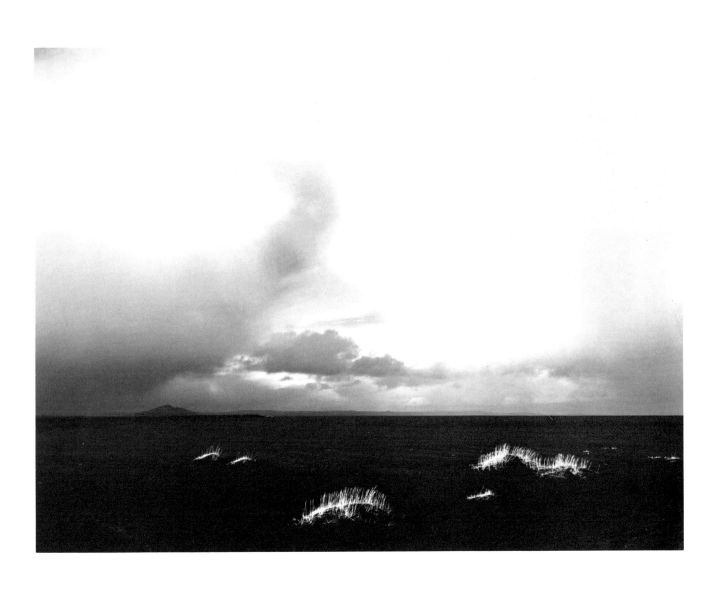

28. MYRDALSSANDER, ICELAND, 1975

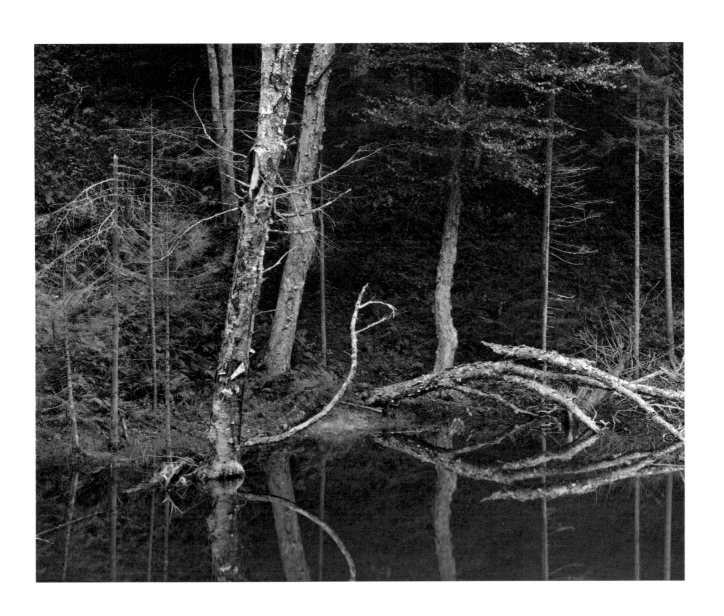

29. WAITSFIELD, VERMONT, 1977

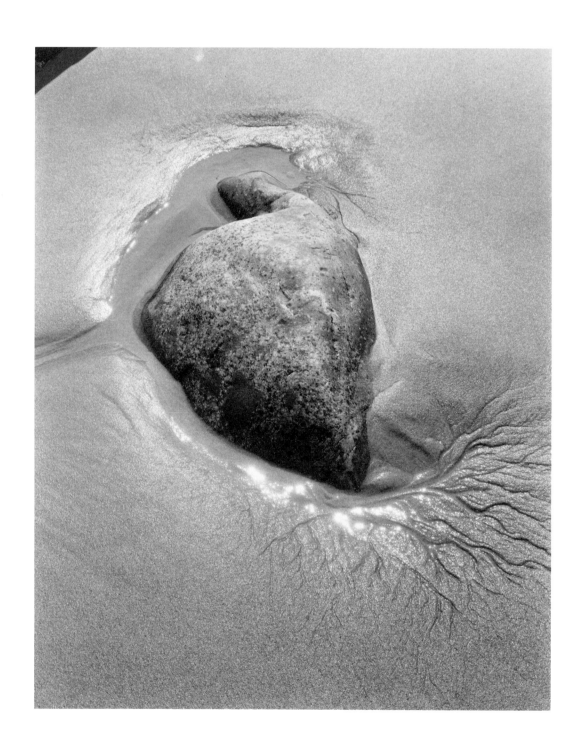

30. RHODE ISLAND, 1972

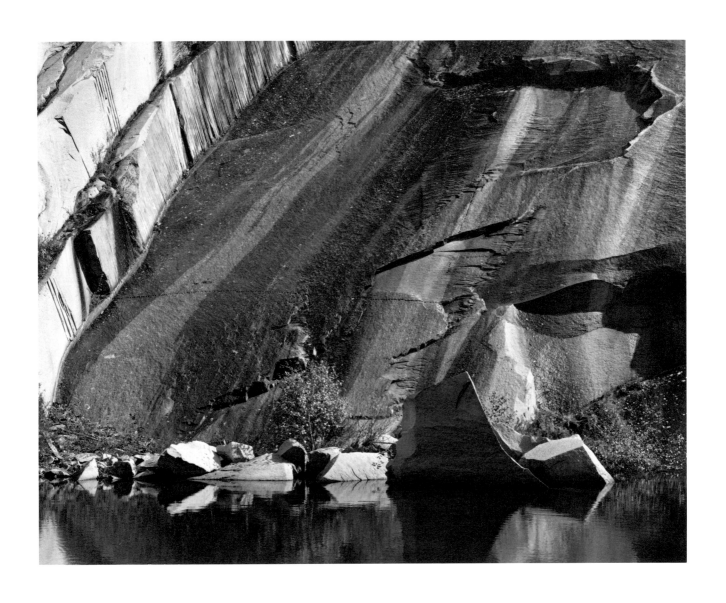

31. DUMMERSTON, VERMONT, 1977

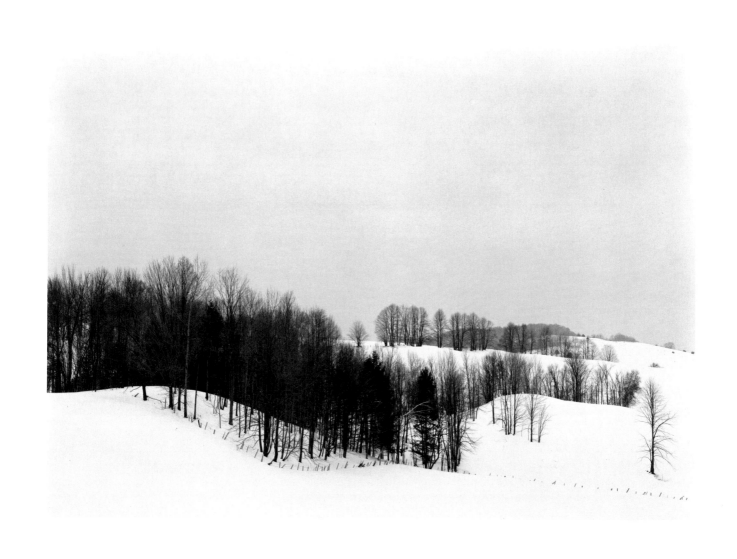

32. WOODSTOCK, VERMONT, 1976

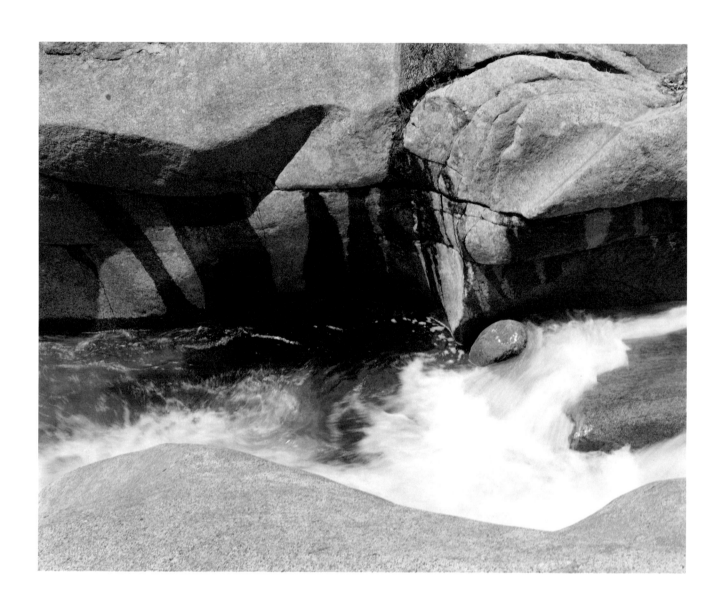

33. BAKER RIVER, NEW HAMPSHIRE, 1977

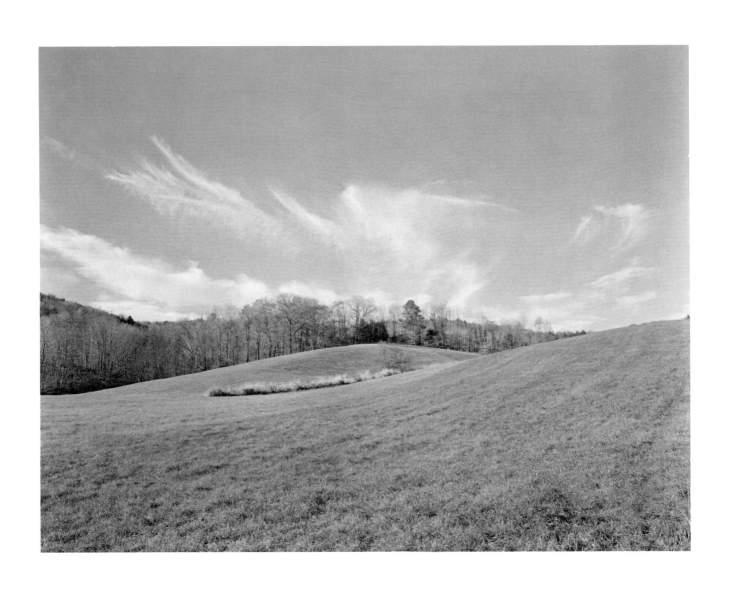

34. WESTMINSTER WEST, VERMONT, 1977

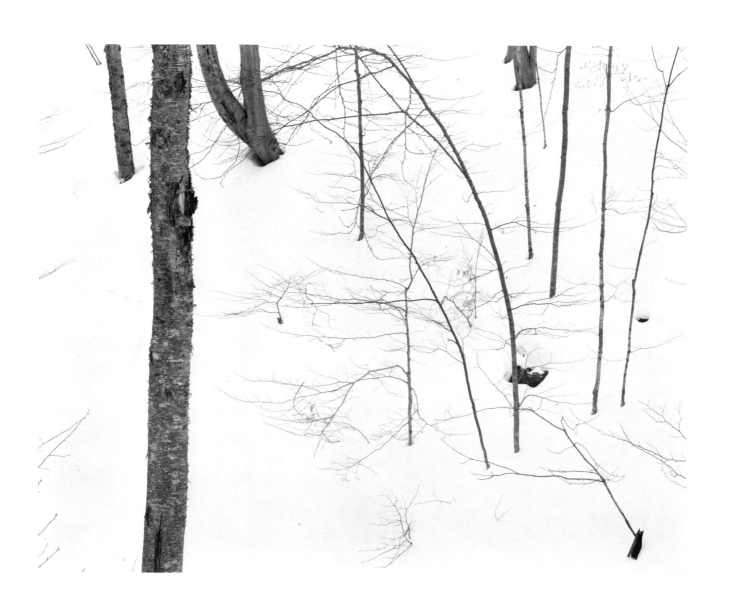

35. GRAFTON, VERMONT, 1977

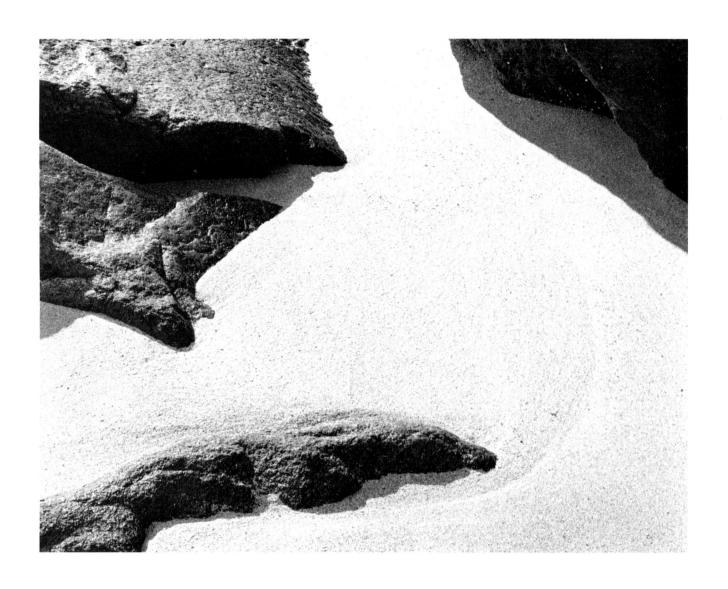

36. SCHOODIC, MAINE, 1977

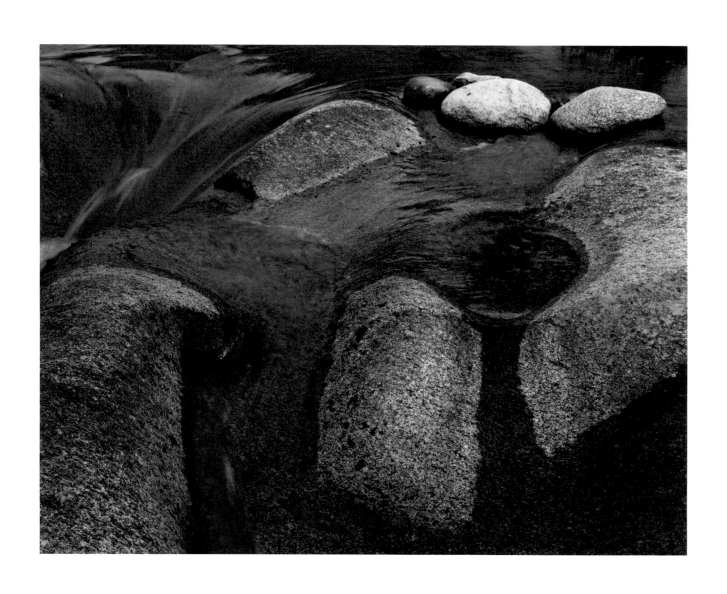

37. EAST PUTNEY BROOK, PUTNEY, VERMONT, 1977

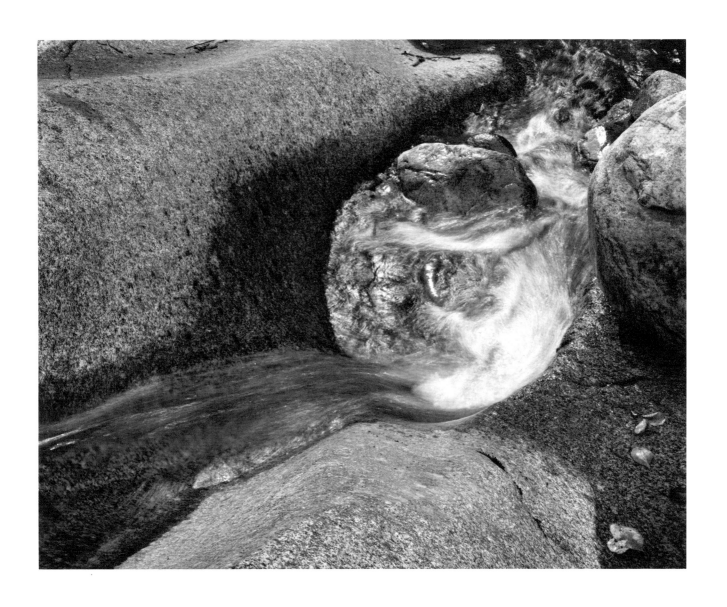

38. GALE RIVER, FRANCONIA, NEW HAMPSHIRE, 1977

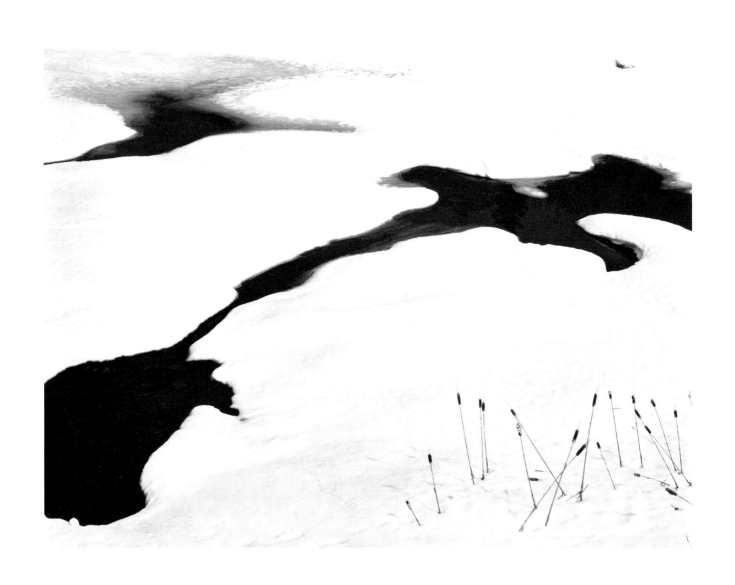

39. GROTON, VERMONT, 1979

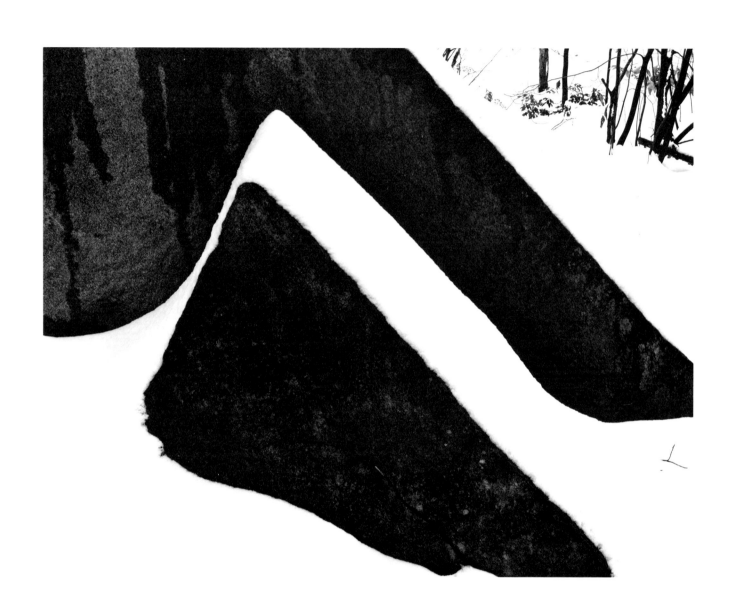

40. DUMMERSTON, VERMONT, 1978

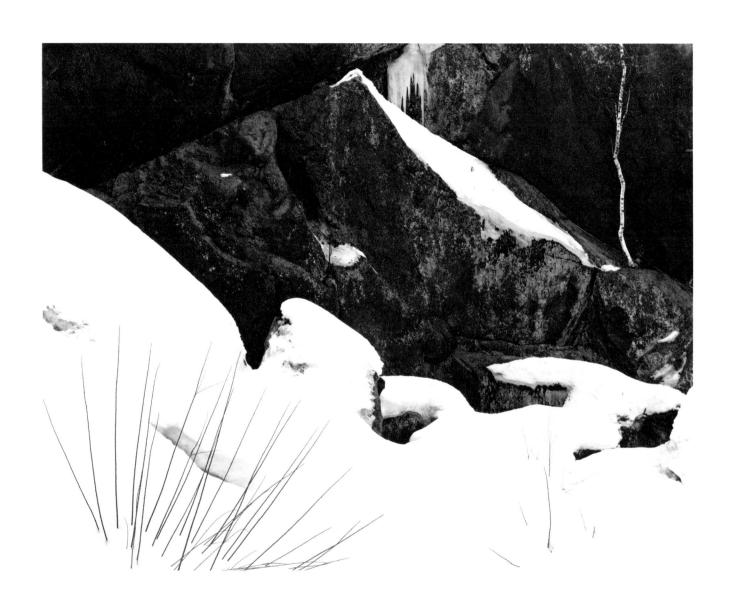

41. EAST ALSTEAD, NEW HAMPSHIRE, 1979

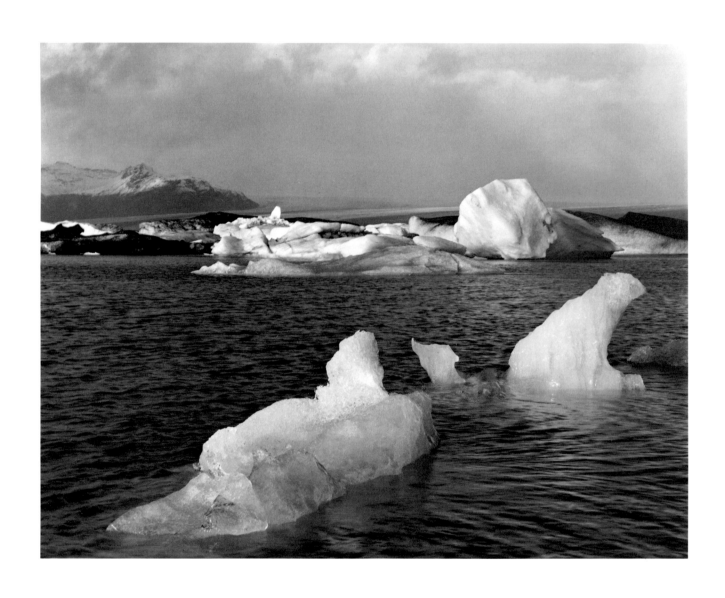

42. SKEIDERARJOKULL, ICELAND, 1975

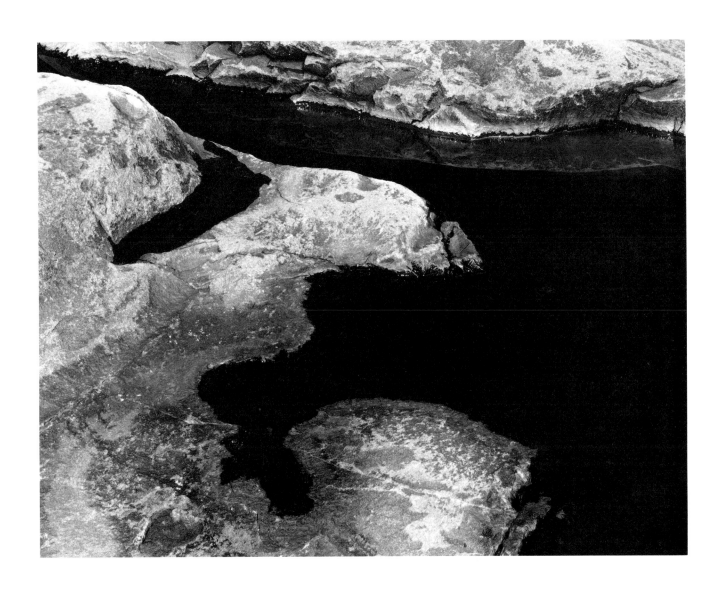

43. SCHOODIC, MAINE, 1977

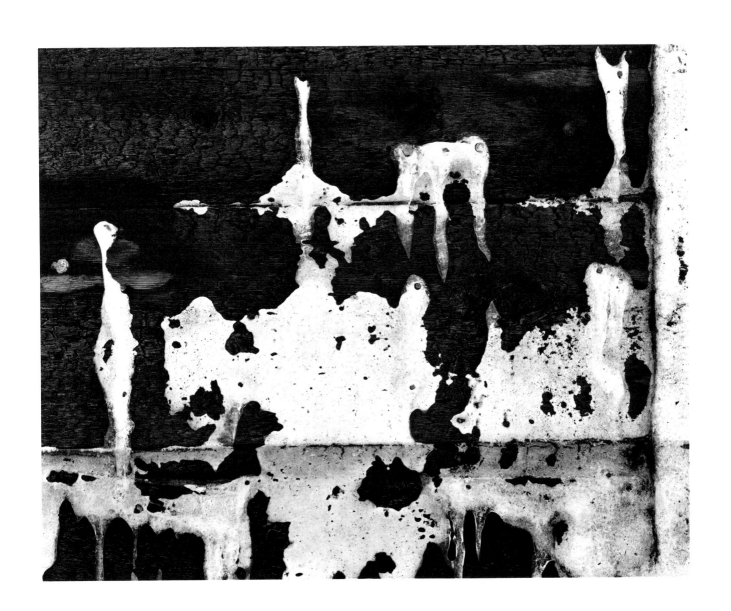

44. BURNT WOOD AND ICE, BELLOWS FALLS, VERMONT, 1975

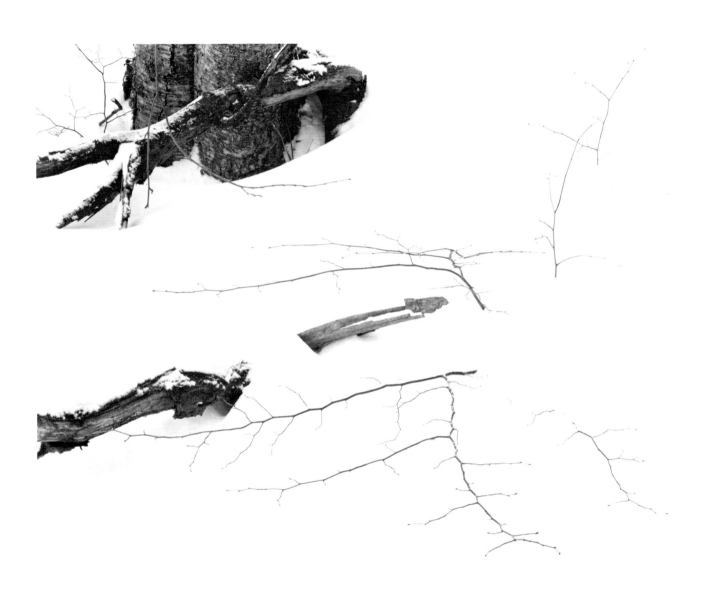

45. PUTNEY, VERMONT, 1978

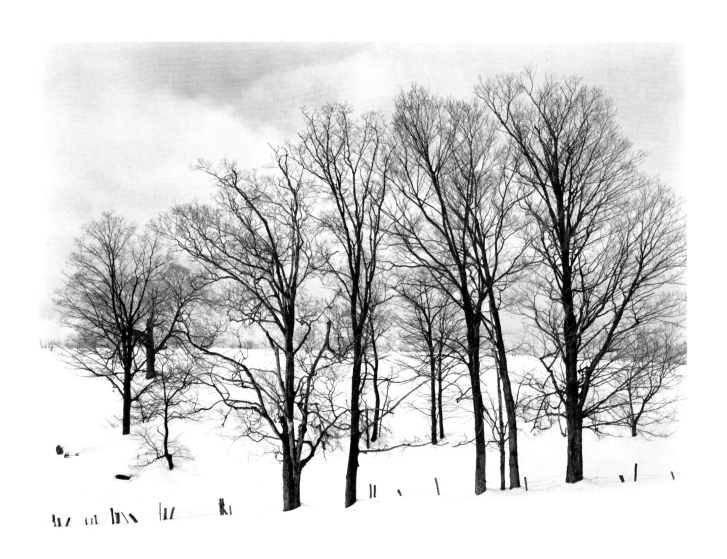

46. WESTMINSTER WEST, VERMONT, 1979

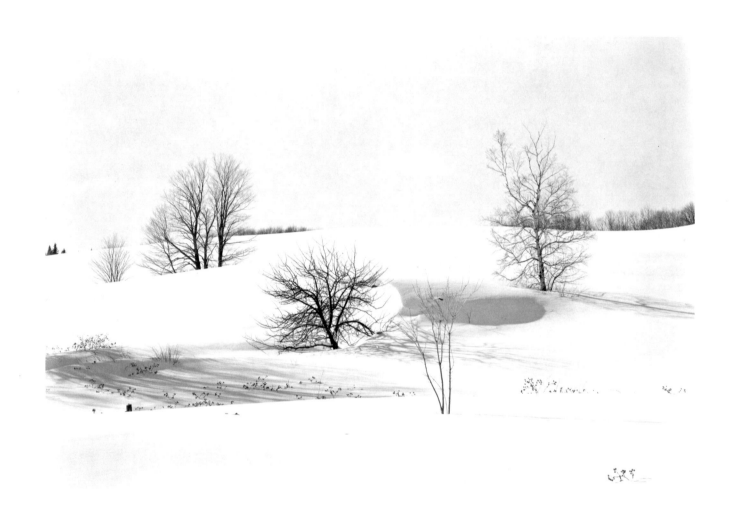

47. CALAIS, VERMONT, 1978

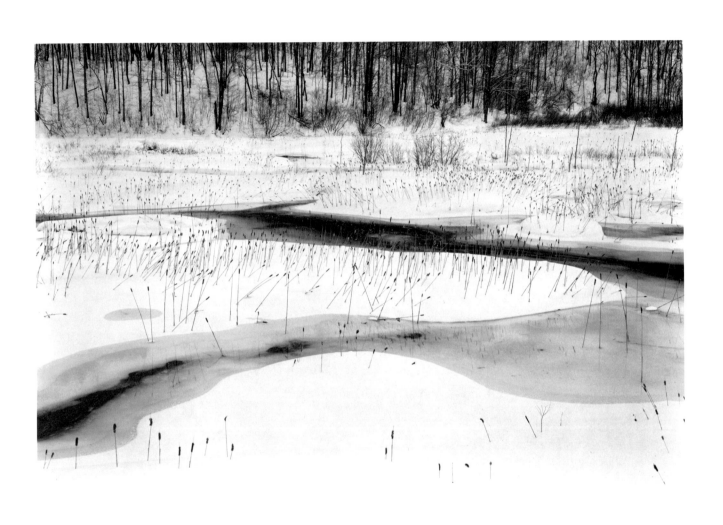

48. EAST BROOKFIELD, VERMONT, 1976

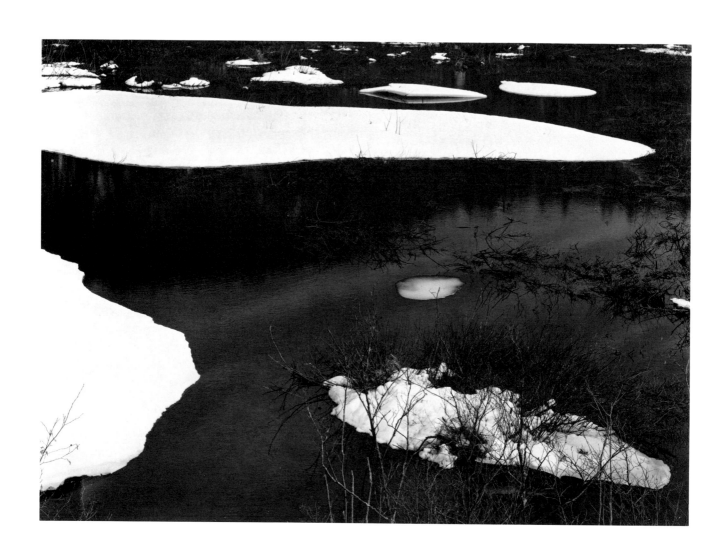

49. ADAMANT, VERMONT, 1978

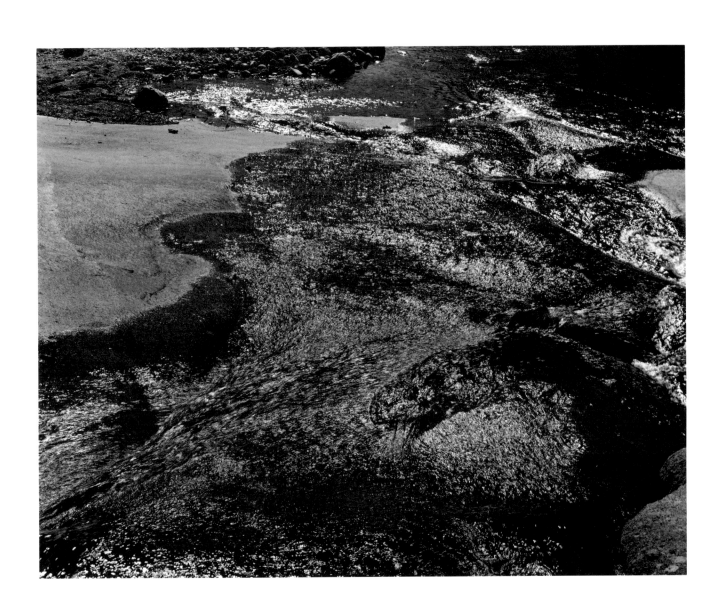

50. STICKNEY BROOK, WEST DUMMERSTON, VERMONT, 1976

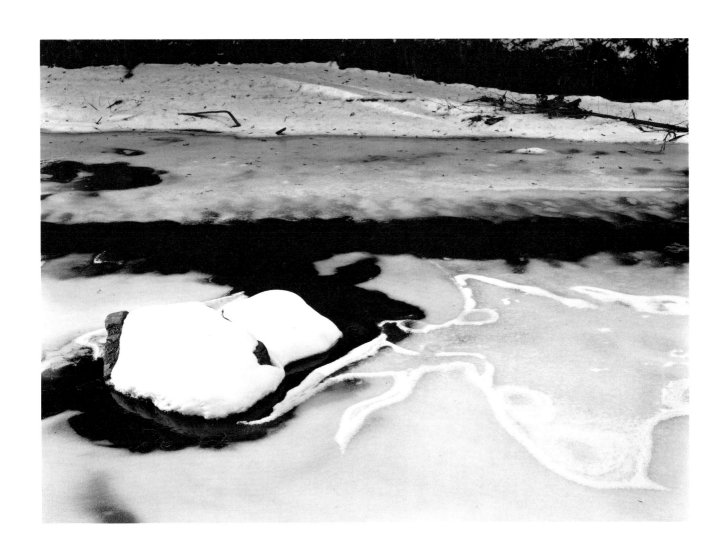

51. SECOND BRANCH, WHITE RIVER, EAST BETHEL, VERMONT, 1978

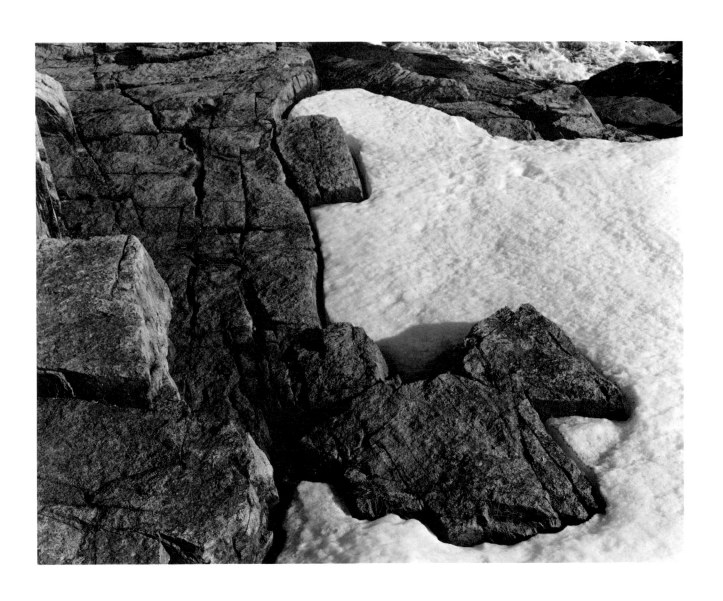

52. SCHOODIC, MAINE, 1977

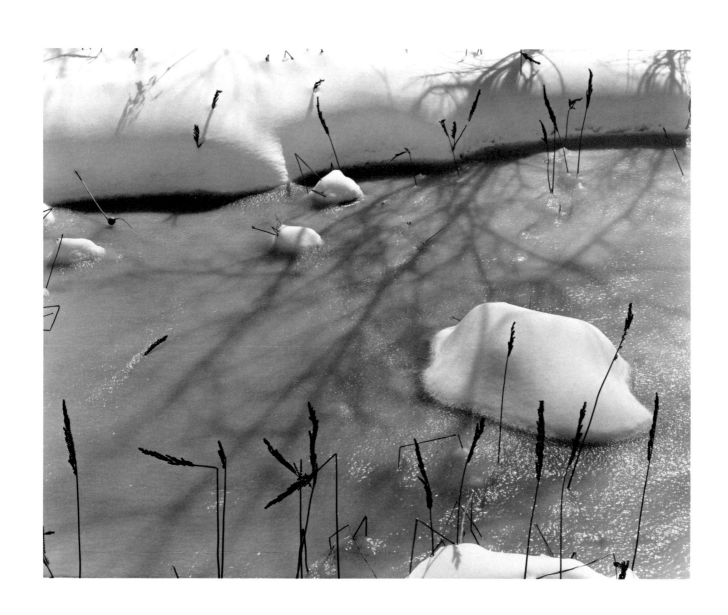

53. HARTLAND FOUR CORNERS, VERMONT, 1977

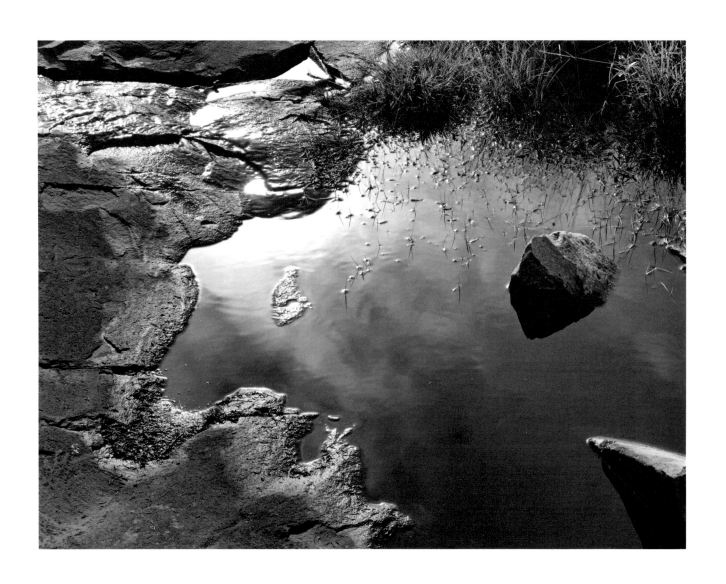

54. MAINE COAST, 1977

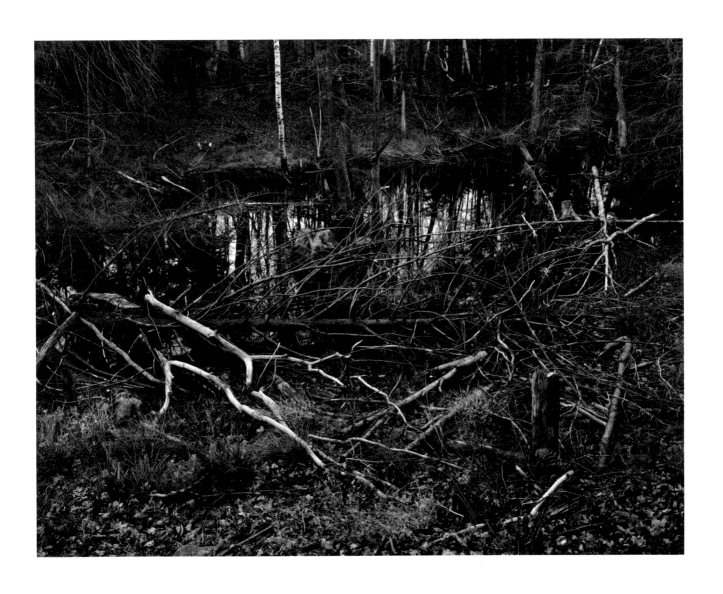

55. MARLBORO, VERMONT, 1978

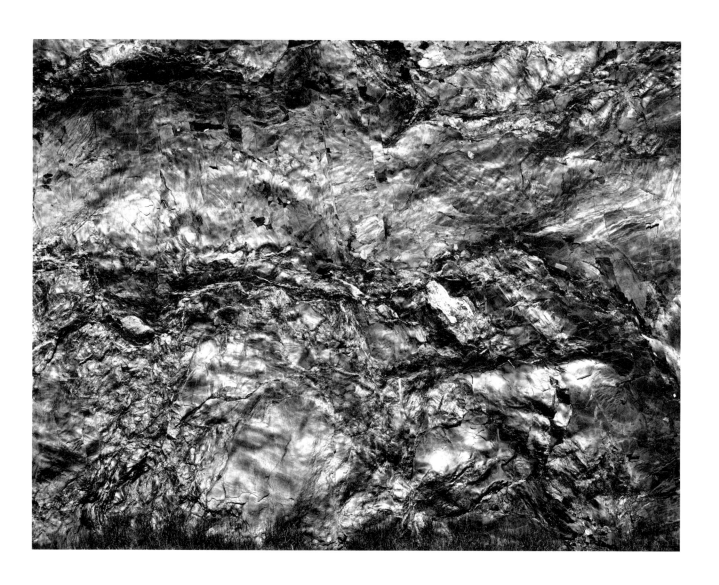

56. QUARRY, VERSHIRE, VERMONT, 1977

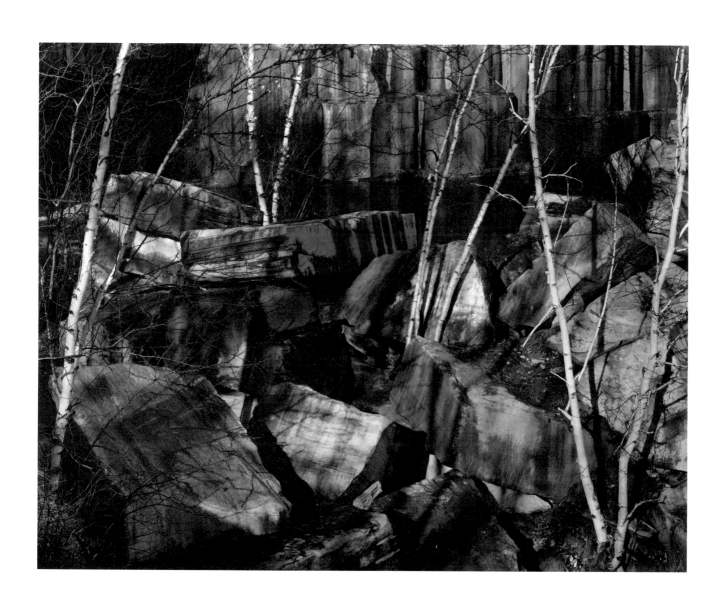

57. QUARRY, DORSET, VERMONT, 1977

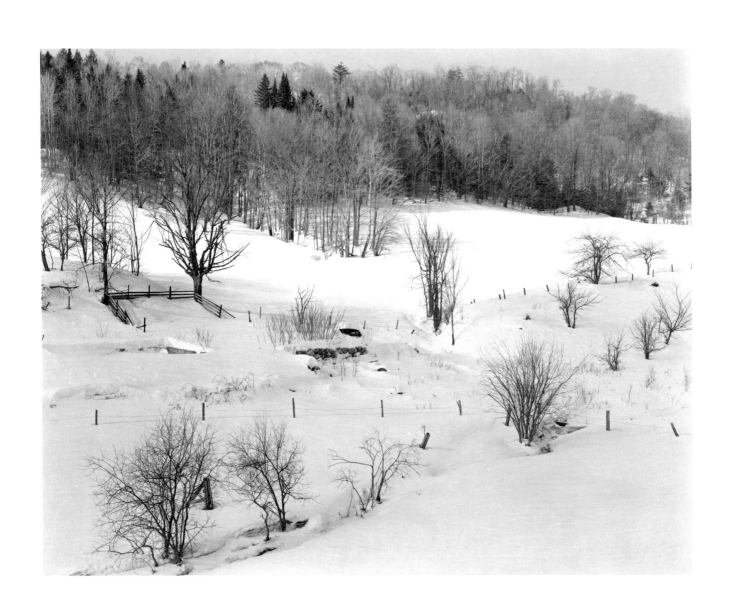

58. PEACHAM, VERMONT, 1976

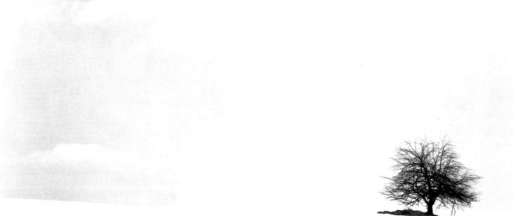

59. TOPSHAM, VERMONT, 1979

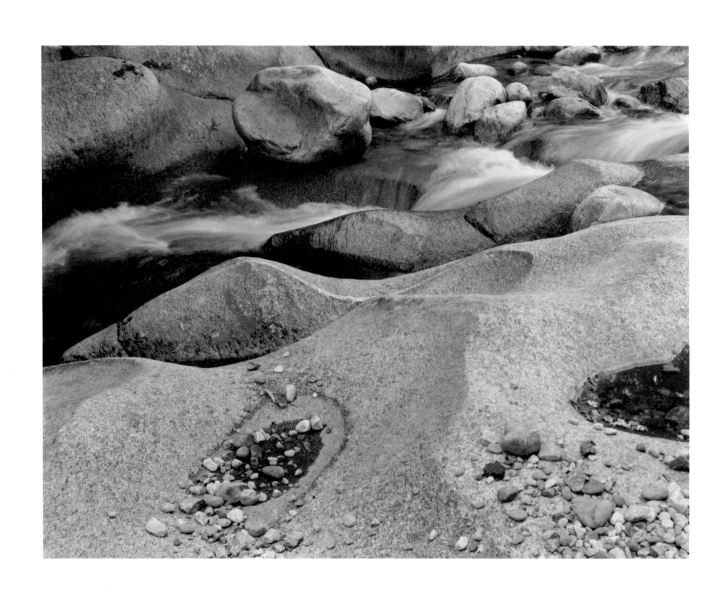

60. BAKER RIVER, NEW HAMPSHIRE, 1977

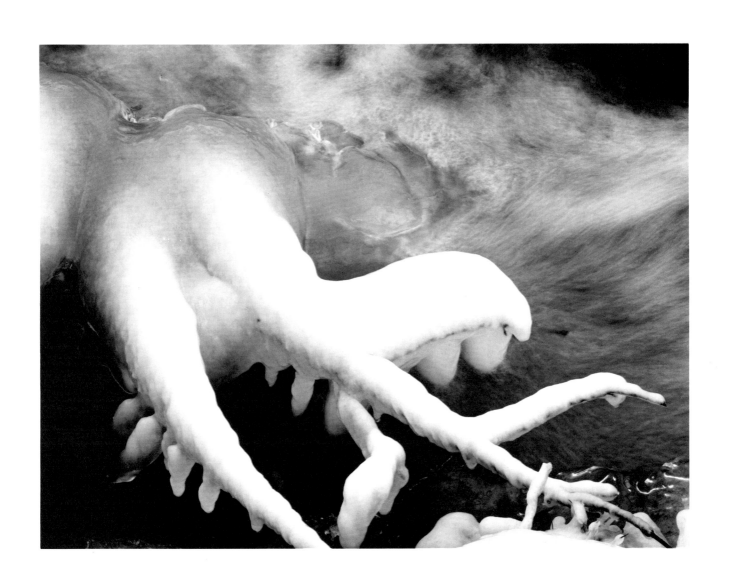

61. WHITE PLAINS, NEW YORK, 1972

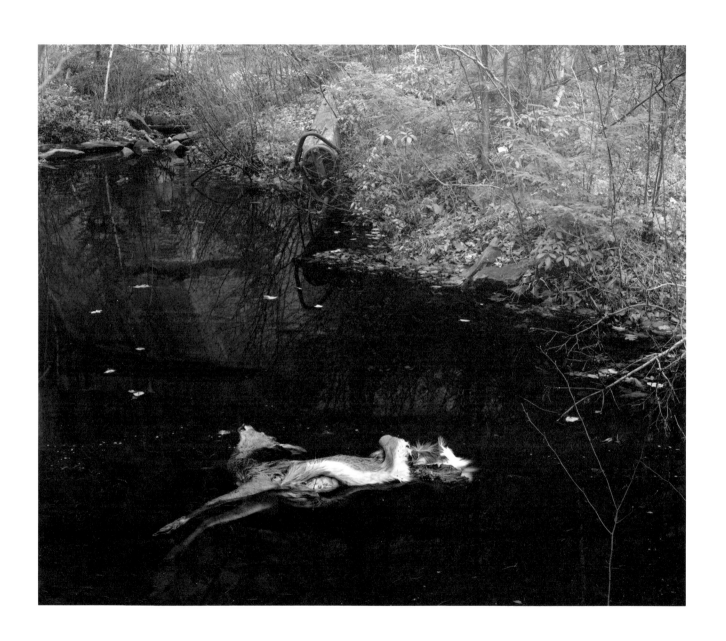

62. DUMMERSTON, VERMONT, 1978

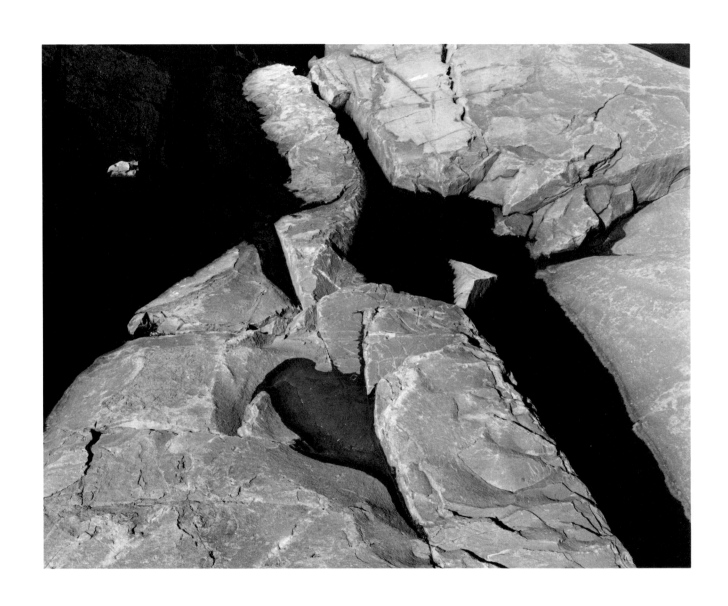

63. SCHOODIC, MAINE, 1977

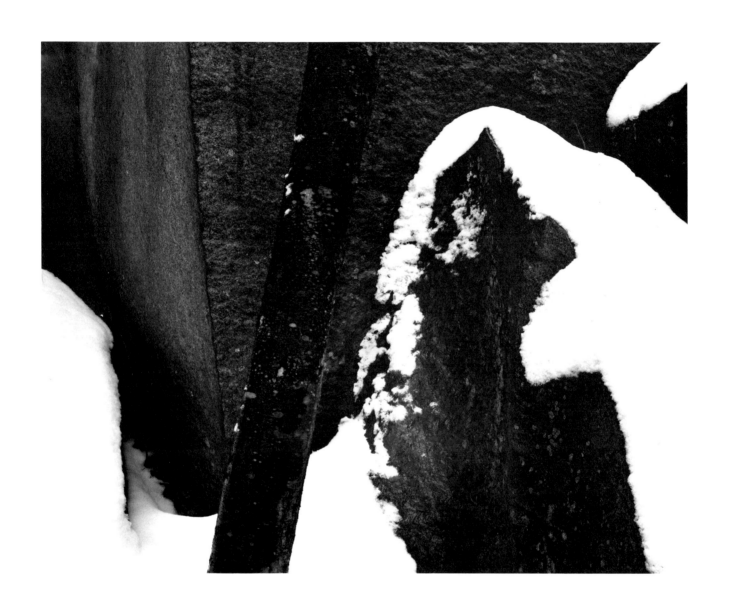

64. DUMMERSTON, VERMONT, 1978

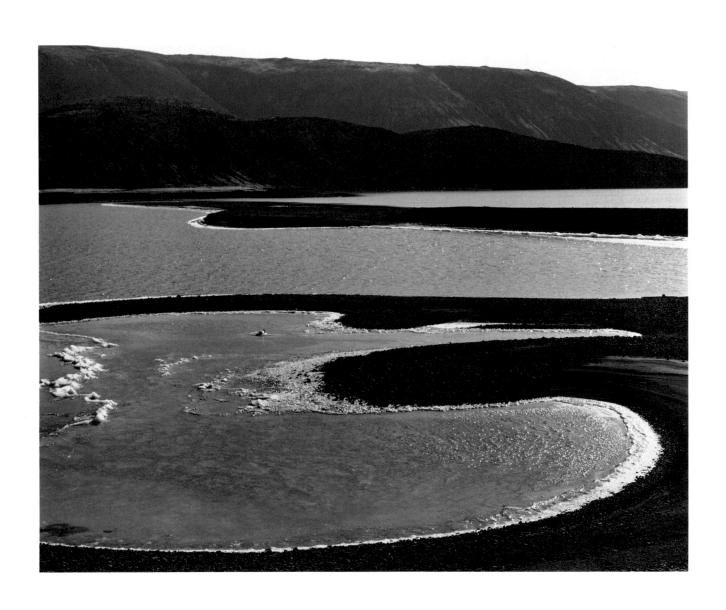

65. KLEIFERVATN, ICELAND, 1974

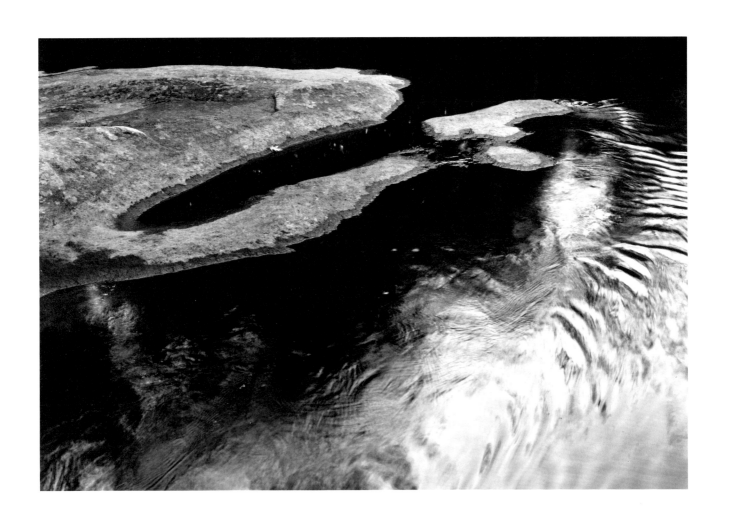

66. BLACK RIVER, COVENTRY, VERMONT, 1972

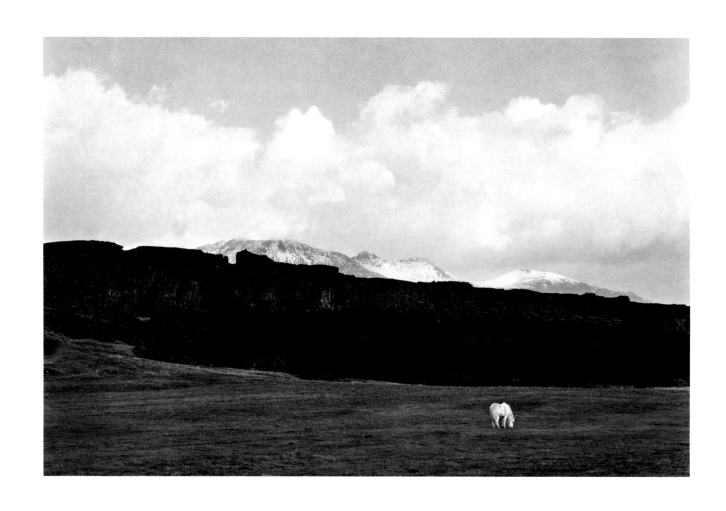

67. THINGVELLIR, ICELAND, 1974

I carry the winter photographs of my friend Fred Picker and I search for a place to be with them again. The rude colors of this California morning, cresting and surging over me, drive me to the white unfurnished room at the top of the house. I lean the photographs against the wall and sit before them on a folding chair, hands open on my knees, offering myself. I breathe and wait.

Soon it comes again, drawing me through the surface of my vision; vision as pitted and abused as the crust of an old moon by the insults daily flung at it and I am returned to that same high cool pure place within myself where these images taught me to go when I first met them. I become very still as I roam through the objects abstracted by Fred's untiring quest for significant revelation; the logic of black waters, the twisting away of a root, the silent fall of a twig at the edge of the melt, the companionship of two surviving grasses at the foot of what appears to be a global frost.

I have my sight again. My outward gaze bathed by snow, arrested by haikus of wood and weed and water is led inwards to a center as lovely as any I have known and I have a sense of soft arrival. These pictures are meditations and like other meditations they do not demand or request attention. They are unmailed invitations to be found in one's own time and way. If you stare at them they vanish; if you narrow your eyes at them, they narrow you. If you are compelled to associate, to say with your inner voice, "Oh, that looks like a face" or "Those are candy buttons," all the mysteries the pictures hold will hide behind their fan.

What you need to do, I think, is to be still and notice lightly with a wide eye and consciousness intact and with no words to say what you are seeing. As you drift from image to image, refusing to describe them to yourself, you will experience an expansion within you, a kinship with the grandeur of the cycles, a slowly growing comprehension and celebration of what is, and a sense that tragedies are as impermanent as winter when you are the cause and the effect of your own being.

When you glimpse yourself as the void through which all passes and persists, then you know, suddenly, that it is you who are the wordless universe.

Stewart Stern
March, 1979
Los Angeles

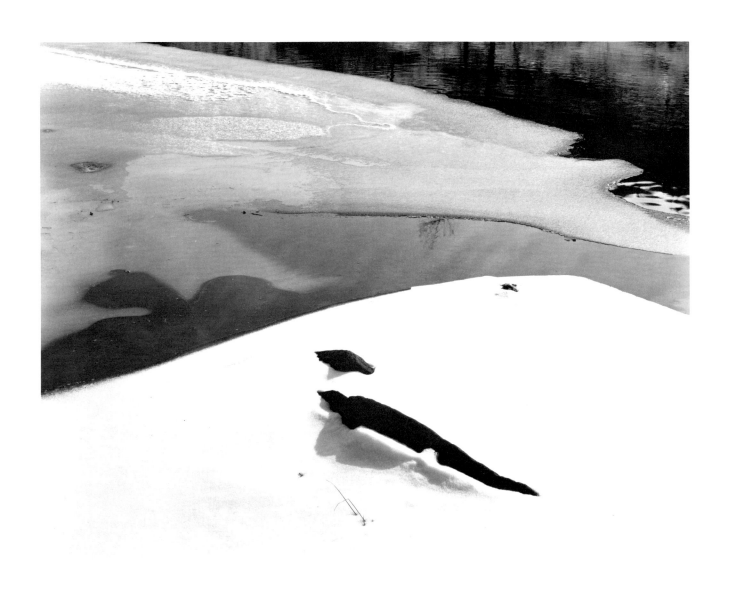

68. DOG RIVER, EAST NORTHFIELD, VERMONT, 1978

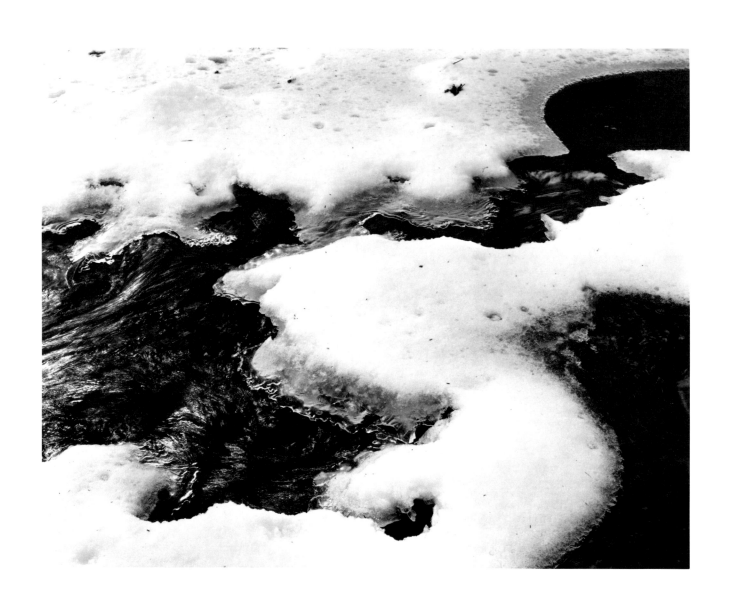

69. FIRST BRANCH, WHITE RIVER, NORTH TUNBRIDGE, VERMONT, 1978

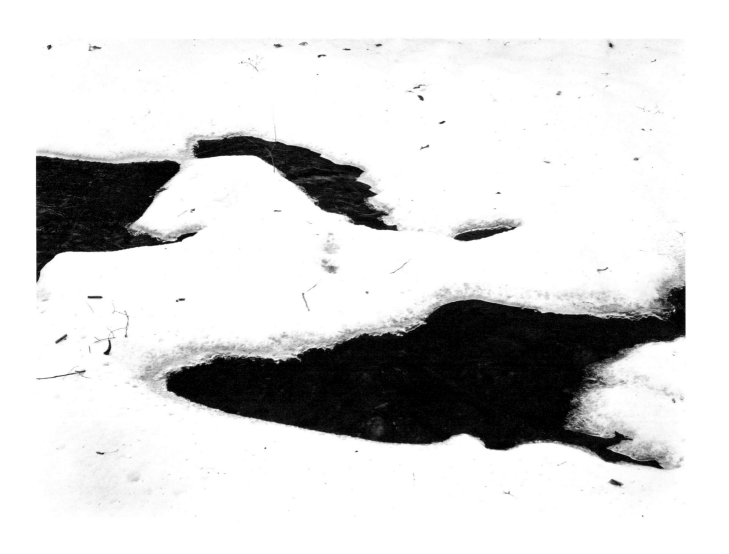

70. FIRST BRANCH, WHITE RIVER, NORTH TUNBRIDGE, VERMONT, 1978

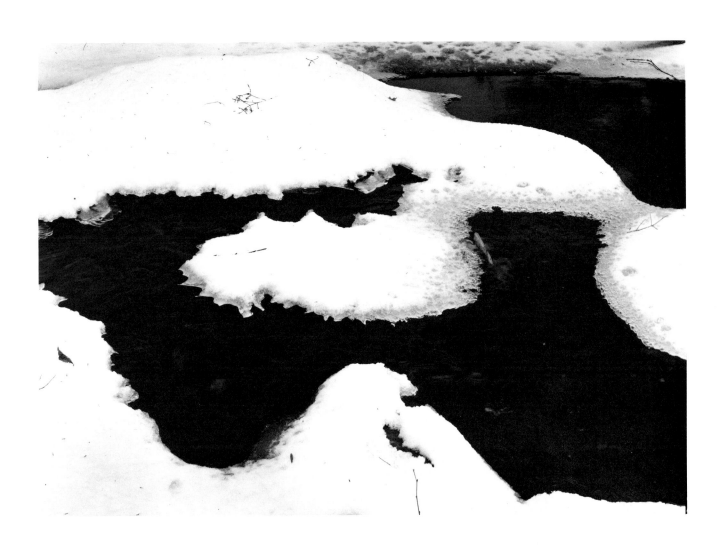

71. AMOS HAILE BROOK, PUTNEY, VERMONT, 1978

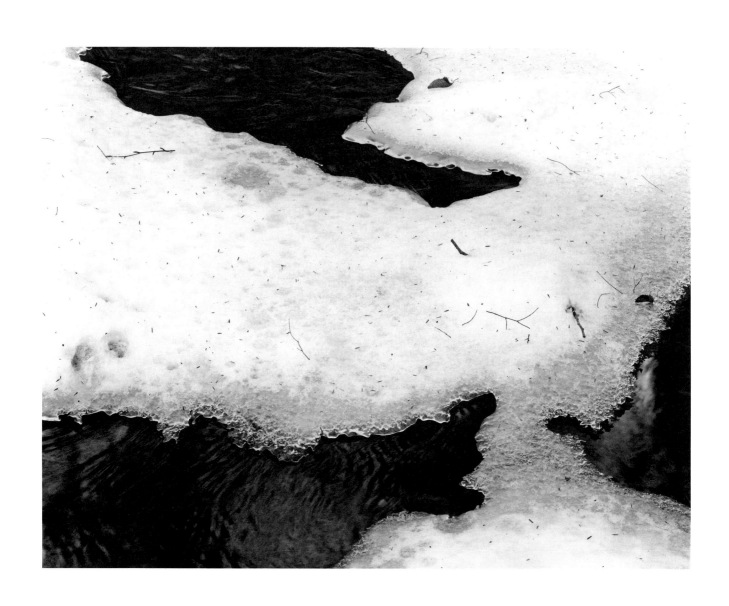

72. AMOS HAILE BROOK, PUTNEY, VERMONT, 1978

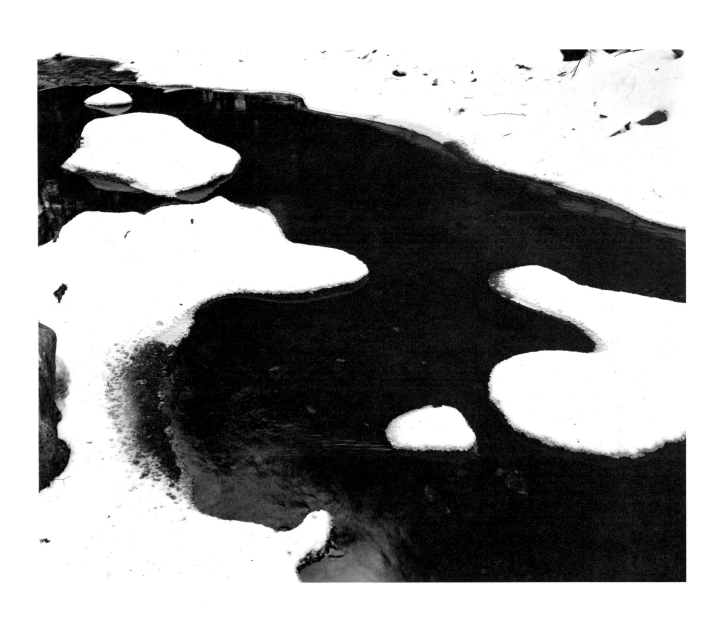

73. AMOS HAILE BROOK, PUTNEY, VERMONT, 1978

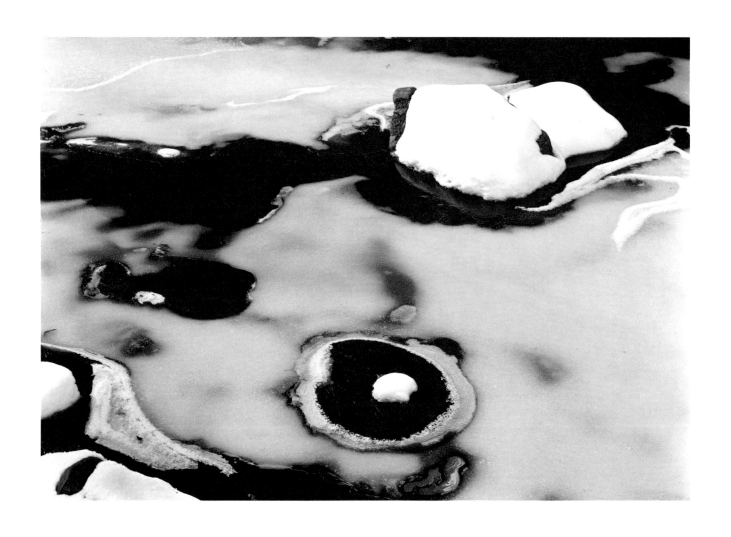

74. SECOND BRANCH, WHITE RIVER, EAST BETHEL, VERMONT, 1978

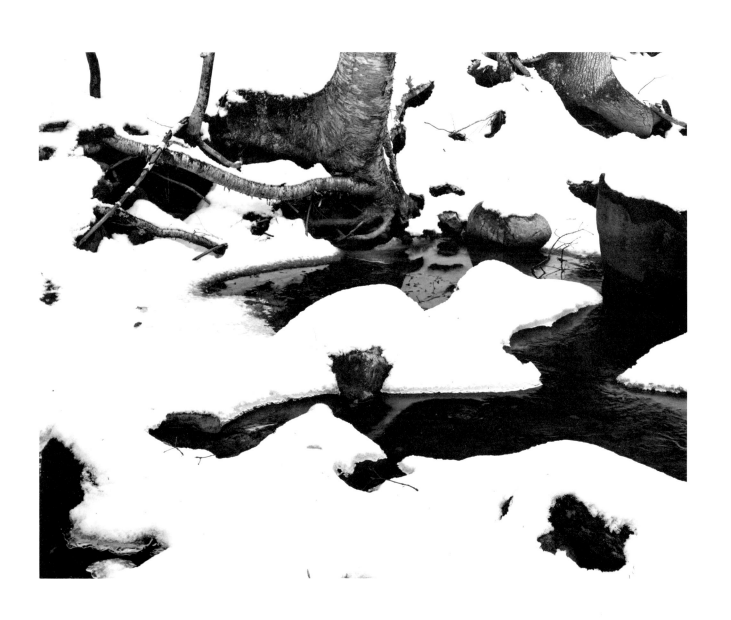

75. AMOS HAILE BROOK, PUTNEY, VERMONT, 1978

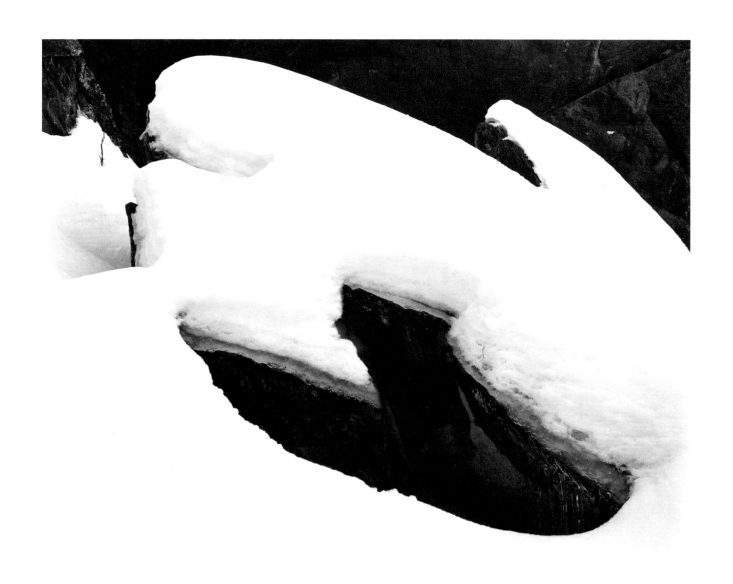

76. EAST ALSTEAD, NEW HAMPSHIRE, 1979

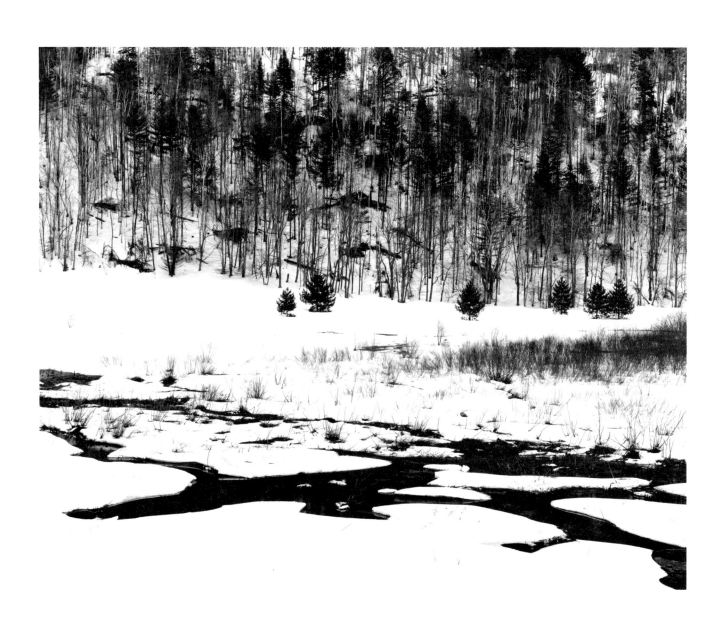

77. TUNBRIDGE, VERMONT, 1978

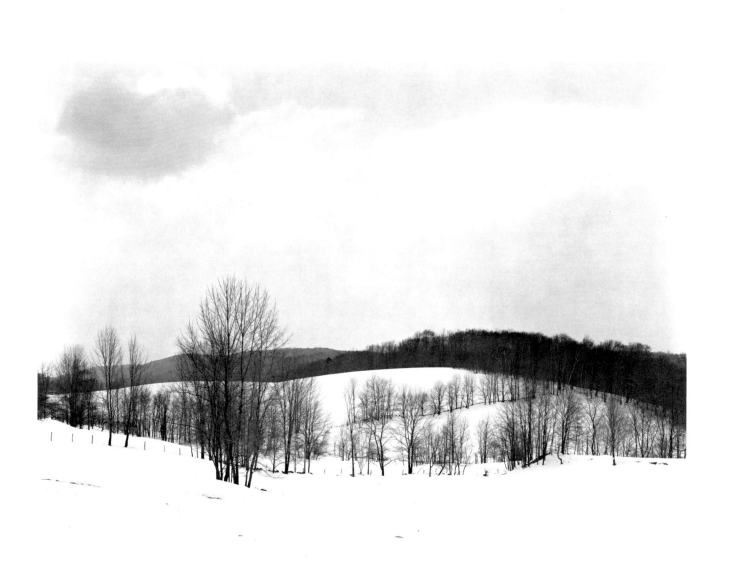

78. WESTMINSTER WEST, VERMONT, 1976

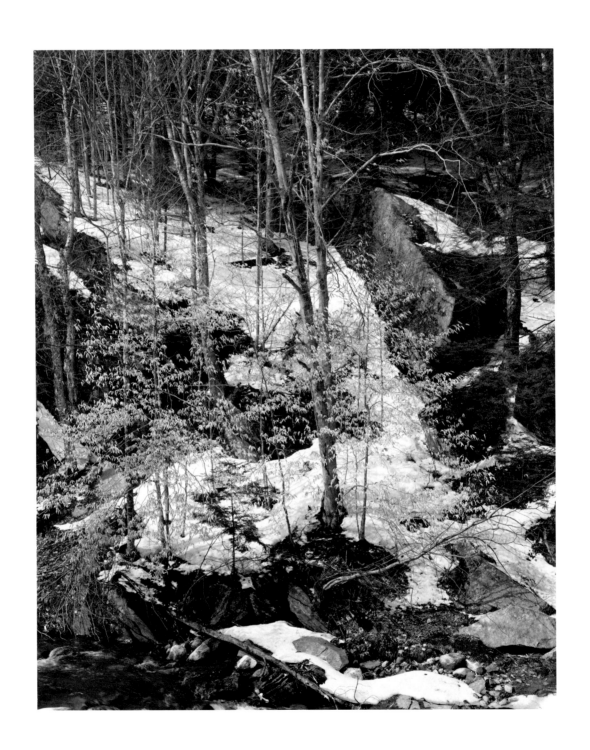

79. LOWER WATERFORD, VERMONT, 1976